GIFTED SISTER

the story of

Fanny Mendelssohn

INLY SCHOOL
46 WATCH HILL DRIVE
SCITUATE, MA 02066

GIFTED SISTER

the story of

Fanny Mendelssohn

Sandra H. Shichtman
Dorothy Indenbaum

**MORGAN
REYNOLDS**

PUBLISHING
Greensboro, North Carolina

Classical Composers

Johann Sebastian Bach
Antonio Vivaldi
Richard Wagner
Johannes Brahms
George Frideric Handel
Giuseppe Verdi
Fanny Mendelssohn

GIFTED SISTER: THE STORY OF FANNY MENDELSSOHN

Copyright © 2007 by Sandra H. Shichtman and Dorothy Indenbaum

Library of Congress Cataloging-in-Publication Data

Shichtman, Sandra H.
 Gifted sister : the story of Fanny Mendelssohn / by Sandra H. Shichtman
& Dorothy Indenbaum. -- 1st ed.
 p. cm. -- (Classical composers)
 Includes bibliographical references and index.
 ISBN-13: 978-1-59935-038-7
 ISBN-10: 1-59935-038-6
 1. Hensel, Fanny Mendelssohn, 1805-1847. 2. Women
composers--Germany--Biography. I. Indenbaum, Dorothy. II. Title.
 ML410.H482S55 2007
 786.2092--dc22
 [B]
 2006030864

Printed in the United States of America
First Edition

To my son and daughter-in-law, Mark and Joan,
who have added flavor and texture to my life
 —Sandra H. Shichtman

To my loving daughter, Esther
 —Dorothy Indenbaum

Contents

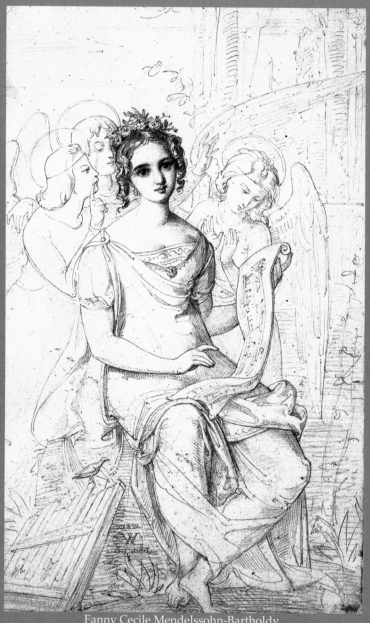

Fanny Cecile Mendelssohn-Bartholdy
(Bildarchiv Preussischer Kulturbesitz/Art Resource)

A Childhood of Privilege

W hen Fanny Cecile Mendelssohn was born, her father proudly reported in a letter that his wife Lea thought their first born child had "Bach-fugue fingers." The baby's strong, active fingers would be perfect for playing the difficult piano music of Johann Sebastian Bach.

It is not surprising that Lea Mendelssohn noticed little Fanny's strong fingers. Lea was a well-educated, cultured woman and an accomplished pianist who had played the works of Bach and other composers for years. The Mendelssohn home in Hamburg, Germany was often filled with music.

Fanny was born on November 15, 1805. Her brother, who was named Jacob Ludwig Felix and would be known throughout his life as Felix, was born on February 3, 1809. Then, on April 11, 1811, another daughter, Rebekka, was born. Fanny would call her sister by the nickname Beckchen.

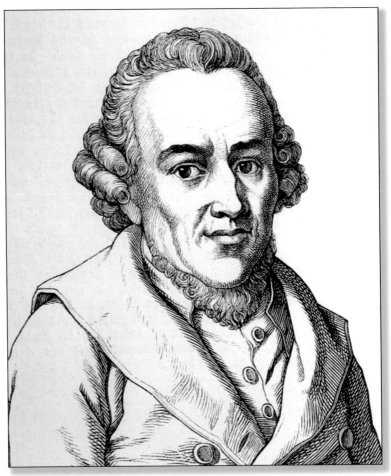

Moses Mendelssohn, Fanny's grandfather, was a famous philosopher.

Fanny's father, Abraham Mendelssohn, was the son of Moses Mendelssohn, a Jewish philosopher, writer, and prominent figure of the Age of Enlightenment. Moses taught Abraham the value of education as a way to overcome anti-Semitism and persecution.

In 1803, Abraham went to Paris to become a bank clerk. He wanted to learn the banking business, and was also anxious to get out of Berlin, where Jews were still heavily oppressed. His sister Henriette lived in Paris and she often talked about her friend, Lea Salomon, who had come to Paris from Berlin.

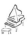

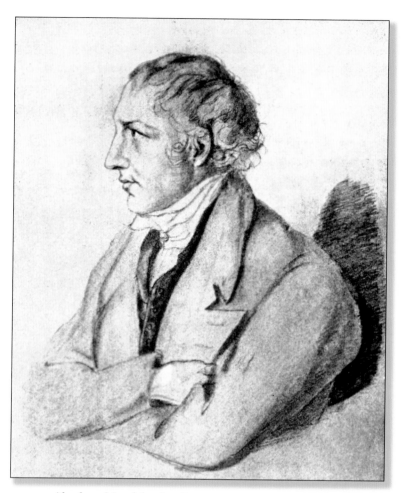

Abraham Mendelssohn *(Courtesy of Lebrecht Music and Arts)*

Like Abraham, Lea came from a family that valued education. By the time she moved to Paris, she could speak, read, and write numerous languages, including French, English, German, and Italian. She was also musically talented and loved to play the piano and sing.

Soon after they were introduced, Abraham and Lea fell in love. They planned to marry, but had to overcome some initial disagreements. Lea's mother was not happy that her daughter wanted to marry a lowly bank clerk, even if he was the son of a famous philosopher. She also wanted her daughter to live in Berlin when she married. Abraham wanted

to remain in Paris. He loved the city's sophistication and the civil rights Jews enjoyed there, while he considered Berlin to be intellectually stifling. But he was in love and was willing to share his life with Lea wherever she wanted to live.

Abraham was further encouraged by his sister Henriette to return to Berlin with Lea. She said he would never truly succeed if he continued to work for someone else, and she worried that Abraham would lose Lea if he remained a mere clerk.

To please both his sister and Lea's mother, Abraham gave up his clerk's job and his life in Paris. He and his older brother, Joseph, became partners in their own bank, Mendelssohn and Company, located in Berlin.

The following year, after Abraham and Lea were married,

they compromised and settled in Hamburg, where Abraham used the money from Lea's dowry to open a branch of the Mendelssohn bank. Lea wrote to her mother, "I married my husband before he had a penny of his own. But

Lea Mendelssohn, Fanny's mother
(Courtesy of Lebrecht Music and Arts)

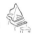

he was earning a certain, although very moderate, income in Paris, and I knew he would be able to turn my dowry to good account."

The Mendelssohn bank flourished and Abraham became one of the wealthiest men in Hamburg. The young couple settled in and, instilled with the notions of education and independence that had been so important to Moses Mendelssohn, Abraham and Lea Mendelssohn began to raise a family.

Unfortunately, Hamburg could not provide a permanent refuge from the greater world of European politics. In the year of Beckchen's birth, 1811, the French armies of Napoleon Bonaparte occupied Hamburg. The French tightened restrictions on German business, and forbade Germans from trading with the British, whom the French were fighting. They blockaded the harbor in Hamburg, so no ships could sail in or out without inspection. Before long, business in Hamburg was at a standstill.

This postcard shows the Berlin birthplace of Felix and Fanny Mendelssohn. *(Courtesy of Lebrecht Music and Arts)*

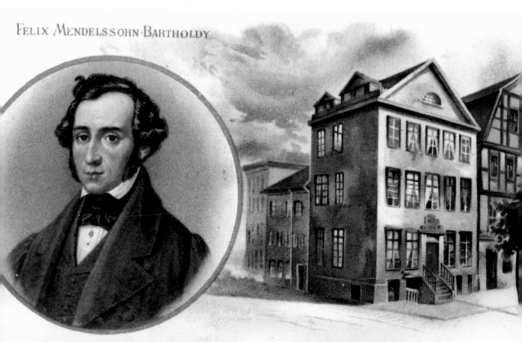

FELIX MENDELSSOHN-BARTHOLDY

The restrictions severely limited the business of the Mendelssohn bank. Abraham decided that his family should leave Hamburg and relocate to Berlin, which the French did not occupy. So the Mendelssohns packed up their household and personal belongings and moved to Berlin, where they moved in with Lea's mother on New Promenade. Once settled, Abraham expanded the Berlin branch of the Mendelssohn bank.

Germany in 1811 was not a single, unified country but a collection of states and principalities. The principalities under French control were forced to send volunteer soldiers to fight alongside their occupiers. In 1812, Napoleon led his army in a massive invasion of Russia and most of the German principalities seized on the chance to sign an accord with Russia and the other European states fighting Napoleon and the French. Abraham Mendelssohn provided substantial amounts of money to equip the German soldiers.

Napoleon's invasion of Russia turned into a disaster. His army was outnumbered and he was defeated and hounded as his weary men tried to make it back to France. After Napoleon was defeated, the Berlin government showed its appreciation for what Abraham had done by appointing him as a municipal adviser in 1813. He would travel frequently in the next few years in order to carry out his duties.

On October 30, 1813, Paul Mendelssohn, Abraham and Lea's last child, was born. Lea Mendelssohn taught all of her children music. As soon as they were big enough to sit on a piano bench, she showed them how to play the piano. Before long, it was apparent that both Fanny and Felix were musical prodigies who would soon need professional teachers.

On March 21, 1816, Abraham and Lea took their four children to the New Church in Berlin and had them baptized

as Lutherans, the official religion of the German state of Prussia, where Berlin was located. Abraham and Lea felt that their children would have a better future as Lutherans than as Jews. Jews were limited in the type of work they could do as adults; as Christians, their opportunities would be limitless.

The conversion of the Mendelssohn children to Christianity was done secretly to keep Lea's mother from finding out. When Lea's brother Jacob Itzig converted and became known as Jacob Bartholdy, his mother disowned him. As far as Lea's mother, Bella Itzig Salomon, was concerned, she no longer had a son named Jacob. Fanny later convinced her grandmother to resume her relationship with Jacob.

Abraham and Lea adopted Jacob Bartholdy's Christian surname for their children. Fanny became Fanny Mendelssohn Bartholdy. The name Bartholdy was a way to differentiate them from the family members who had not converted to Christianity.

Later that year, Abraham, now an important Berlin banker, was sent to Paris on government business. His job was to settle the French war indemnity—to tell the French how much money they needed to pay Germany for waging war against it. Abraham took his entire family and household staff with him to Paris, where the children met their aunt Henriette Mendelssohn for the first time.

The children were kept busy. They saw the sights of Paris and visited family members who lived there, including Abraham's brother, Joseph. They attended concerts with their aunt Henriette.

In 1816, Fanny and her brother Felix began studying piano with Marie Bigot, an esteemed teacher. Bigot was also a

composer, but was best known for playing the music of the composers Joseph Haydn and Ludwig von Beethoven. It is said that Beethoven was so impressed with her interpretation of his music that he dedicated one of his piano sonatas—a musical composition for one or more instruments—to her.

Bigot and her husband had lived in Vienna, Austria, when Napoleon invaded it. After Napoleon was defeated, the Austrians fired Bigot's husband from his job because they were French. The couple returned to Paris, where Marie Bigot earned a living as a piano teacher.

Bigot also played chamber music, which is music written for two or more instruments. The most common forms of chamber music are trios, quartets, and quintets. For example, a string quartet consists of two violins, a viola, and a cello. A piano quintet consists of a piano, two violins, a viola, and a cello.

Through Bigot, Fanny and Felix were introduced to Pierre Baillot, a violinist and composer, who also played chamber music. Baillot became so fond of the children that he agreed to coach them. This broadened Fanny's and Felix's musical knowledge. Henriette described Baillot's fondness for the children to Lea, "You know Baillot's sensitive face, this expression remained as long as he spoke of Fanny and Felix and we spoke of no one else."

When the Mendelssohns returned to Berlin in 1818, Abraham hired Ludwig Berger, an acclaimed pianist and teacher, to continue his eldest children's musical education. He also hired Carl Friedrich Zelter, the director of the famed Berlin music school, the Singakademie, to teach them musical theory and composition. Together, Berger and Zelter gave Fanny and Felix a thorough grounding in the music of Johann

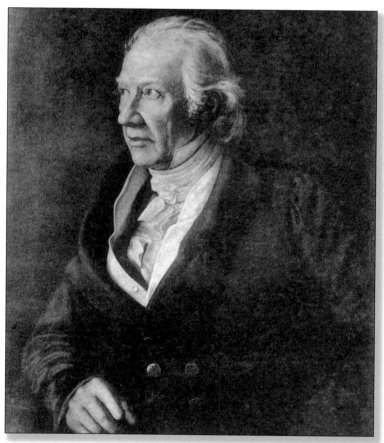

Carl Friedrich Zelter, director of the famed Berlin Singakademie, was hired to teach Fanny and Felix musical theory and composition.

Sebastian Bach, Wolfgang Amadeus Mozart, and Ludwig von Beethoven. Bach, Mozart, and Beethoven would influence Fanny's musical taste and her composing style.

For nonmusical subjects, Abraham hired Karl Heyse to teach his children French, Italian, English, mathematics, history, geography, science, drawing, and dancing. Fanny also learned how to sew and embroider and to run a household.

The Mendelssohn children were up at five o'clock every morning. Their days were filled with the study of music and

academic subjects with little idle time. While her children practiced the piano, Lea habitually sat in the room listening, knitting, reading, and keeping a close watch on their progress.

Abraham was also deeply involved with his children's education. He traveled often on business, but kept track of their progress through letters. In 1819, he returned once again to Paris, this time on an extended business trip. Throughout his almost yearlong absence from home he kept in constant touch with his children in Berlin. Sometimes he wrote specifically to one person, but mostly his letters were meant to be read by everyone in the family and he included individual paragraphs for each child.

In one letter that he wrote to his family, he told Fanny, "Of your two letters, my dear Fanny, the second . . . was more correctly and carefully written than the first. . . . You are now old enough to find subjects to write to me about, not only in the daily events, but also in your thoughts."

When Fanny's letter writing improved, he wrote, "I cannot deny myself the pleasure, dear Fanny, to tell you in a special letter how much your last letters have pleased me. They are carefully and well written, and you have at last discovered the secret to write to me about yourself and the others with real sense and feeling."

Besides doing their lessons and practicing the piano, the children's lives were filled with visits to and from their relatives. The Mendelssohns were a close-knit family and their playmates, besides each other, were mainly their cousins.

Fanny was close to both her Salomon and Mendelssohn cousins. Marianne Seligman, the daughter of one of Lea's sisters, was an especially close friend. Marianne eventually

married Alexander Mendelssohn, the son of Abraham's older brother, Joseph. Fanny and Marianne would remain lifelong friends as well as cousins and would confide in each other throughout their lives.

Fanny and Felix soon began to compose their own songs. Fanny was older and her songs were more mature than Felix's. She looked at his musical compositions and commented on how they could be improved. As Felix got older, Fanny showed him her own compositions and sought his comments on their improvement. This is a ritual the siblings would continue for the rest of their lives.

During the summer of 1819, the Mendelssohns vacationed at a dairy farm near the Silesian Gate in Berlin. Fanny's grandfather, Daniel Itzig, had bought the farm and many of her Itzig and Salomon relatives spent time there. Fanny continued to work on her music while the summer passed peacefully by.

In August, she wrote to Carl Friedrich Zelter to tell him of her progress.

> My musical concoction is progressing rather slowly. It is at times pretty difficult for me; especially the songs are giving me a lot of trouble. I have completed the gavottes (French folk dance music), that is, twelve of them down on paper, but you will certainly find fault with much that is there. I am rushing now with the songs in order to finish them before our departure.

In December 1819, when she was fourteen, Fanny composed her first song, which she called "Ihr Tone, schwingt euch frohlich!" (Songs, Fly Joyously Away!)

Once it was apparent that Fanny and Felix were exception-ally gifted musicians, Lea Mendelssohn began to arrange for them to perform at musicales in their home. Both parents were used to having large gatherings of people in their home from their own childhoods. Abraham's father, Moses, had always invited artists, critics, and writers into his home. Lea remembered the musicales her mother had given in their home when she was a young girl.

Musicales were a tradition throughout eighteenth- and nineteenth-century Europe. They were often called "salons" because they were usually given in the parlor room, or salon, of a house. They were private gatherings of invited guests from all walks of life, held on a regular basis, and run mostly by upper-class women. Most of these women did not work outside the home and this was a way to interact with the world. The guests could include intellectuals, politicians, musicians, artists, and writers, as well as family members and friends. They would eat and drink, discuss art, politics, and religion, and listen to music, as well as exchange the latest news about what was happening in the world. For Lea Mendelssohn, they were also a way to show off her eldest children's musical talents.

In 1820, when Fanny made her confirmation in the Lutheran church, Abraham, who had gone back to Paris on business, wrote to her. He told her that Judaism had been the reigning religion thousands of years ago but that was no longer the case. Christianity had replaced Judaism as the religion of most people of the world. "We raised you and your brothers and sister to be Christians because that is the form of belief of most civilized people. . . . In professing your faith you have accomplished what society required of you."

That same year, Fanny and Felix joined the respected Berlin Singakademie (Music School), where they sang in the chorus. Fanny's singing voice was deep and she sang alto. Felix sang soprano at first. Later, when his voice matured, he became a tenor. Neither Fanny nor Felix had a particularly fine singing voice, and neither was ever chosen to be a soloist. However, from time to time, Carl Friedrich Zelter, who was the director of the music school, allowed one or the other to play the piano while the chorus rehearsed. Because Fanny was older, she was a more accomplished pianist and was given more opportunities to play the piano at rehearsals than her brother.

The Berlin Singakademie was founded in 1791 by a group of prominent composers and musicians. Its purpose was to bring the music of previous generations of composers, such as Bach and Mozart, to eighteenth-century audiences. It was also a place for modern composers to have their music performed. The Singakademie became very important in the musical life of Berlin.

Carl Friedrich Zelter was a violinist and composer. He was also a friend of Johann Wolfgang von Goethe, the German poet and philosopher, some of whose poems Zelter set to music. Zelter was one of the founding members of the Singakademie and had become its director after the death of the founding director in 1800.

By the time Fanny and Felix joined the Singakademie, new members had to be recommended by an existing member, or they had to pass a test before they could get in. What better than to be recommended for membership by the director who was also their teacher? Even so, it was an honor for them to be accepted at their young ages. In 1820, Fanny was fifteen; Felix was eleven.

Even though both were very young, Zelter recognized their talent and allowed them to take part in the concerts given every Friday at the Singakademie. They were encouraged to continue composing as well. Because she was female, Fanny was urged to compose songs and piano pieces that could be sung and played in the home. Felix, on the other hand, was urged to compose larger and more complex pieces that could be played in a concert hall. In 1820, Felix composed several sonatas, chamber music, religious music, and a cantata—a story sung by a chorus. This was the first time in their musical education that they were taught differently because of their sex. It would not be the last.

Discouragement

two

By 1820, Fanny Mendelssohn was no longer considered a child, and Lea and Abraham began to look for a suitable husband for her. They insisted that he had to be a Protestant, financially secure, and someone who would fit into their social circle.

There was also a noticeable change in Carl Friedrich Zelter's attitude toward her. He continued to encourage Felix as a musician and composer and to give him opportunities to showcase his talent. But, while Fanny continued to sing in the chorus at the Singakademie, her efforts to compose were no longer encouraged.

Fanny did not understand why Felix was urged to continue composing while she was not. She and Felix had spent almost all of their time together, had studied together with their music teacher, Ludwig Berger, and Karl Heyse, their tutor, had taught both their academic subjects. Now, Zelter seemed

to have lost interest in Fanny's musical talent. Regardless, she continued to compose songs and pieces for the piano. Between 1820 and 1821, she wrote thirty-eight songs, eleven piano pieces, and various other musical compositions.

In January 1821, the Mendelssohn family visited the studio of Wilhelm Hensel, a painter who had done several portraits for Grand Duke Nicholas of Russia. Before sending the portraits to Russia, Hensel exhibited them in his studio.

Wilhelm Hensel, the son of a poor pastor, was born on July 6, 1794, in the town of Trebbin in the Brandenburg region outside Berlin. His father wanted him to become a mining engineer and to please his father he had studied mining for a while. But Hensel preferred to draw pictures and write poetry and, after his father's death in 1811, he began to study painting at the Academy of Fine Arts in Berlin. During the Napoleonic Wars he served for three years in the Prussian army and was wounded several times. At the end of his service he went to Paris, visited its museums and studied its paintings, before traveling on to Rome to study the paintings of the old masters.

On his return to Berlin, Hensel began to paint and soon began to receive commissions to paint the portraits of German nobility. His portraits caught the attention of the Prussian emperor, Frederick William III, and in 1821 he received a commission to paint twelve tableaux vivants (living pictures) based on Thomas Moore's poem, "Lalla Rookh." Hensel painted the portraits of the costumed nobility who acted out the poem in a theatrical spectacle set in Persia. The paintings were to be presented to the guests at a festival to honor the visit of Crown Prince Nicholas of Russia and his wife, Princess Charlotte. It was these paintings that were exhibited

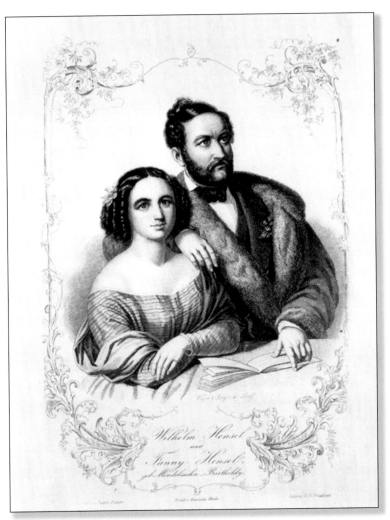

Fanny and Wilhelm Hensel

in Hensel's studio when the Mendelssohn family visited.

Abraham and Lea Mendelssohn were impressed by Hensel's artistic talent and invited him to their home to paint their portraits and those of their children. While working on the paintings Hensel fell in love with Fanny, but hesitated to let her know how he felt. When he finally asked her to marry him several months later, she asked him to talk to her parents to get their approval.

Lea had doubts about Hensel's suitability. At twenty seven,

might he be too old for Fanny? How would a poor artist support her properly? Was he after her dowry money? Despite these reservations, the Mendelssohns eventually gave their consent for the marriage, but Lea asked Hensel to keep his affections for her daughter a secret so her own mother would not find out about it. Not only did the eighty-year-old Bella Salomon still not know about her grandchildren's conversion to Christianity, she would not be pleased to find out that Mendelssohn's husband-to-be was also a Christian.

Another religious complication was that Hensel was considering converting to Catholicism, which would put him in a minority in heavily Lutheran Prussia. Fanny knew very little about Catholicism, but promised to learn something about the religion. During one of Hensel's visits to the Mendelssohn home, Lea asked him if he was going to convert to Catholicism. He answered with a question of his own. Would the Mendelssohns take back their consent to his marriage with their daughter if he converted?

Fanny Mendelssohn was upset by the conversation and fled the room in tears. She was in love with Hensel, as he was with her, but knew she could not tell her parents how she felt. It was not proper for an upper-class young lady to talk about her feelings, especially romantic love.

When Hensel could not give the Mendelssohns his word that he would remain a Protestant, Lea told him she would do all she could to persuade her daughter not to marry him if he converted. She suggested that the two young people not see each other alone while he remained in Berlin. He was also forbidden to write letters directly

to Fanny, but was permitted to write to Lea. She explained her decisions to Hensel:

> You must not be angry with me . . . Fanny is very young . . . I'll not have you, by love-letters, transport her for years into a state of consuming passion and a yearning frame of mind quite strange to her character, when I have her now before me blooming, healthy, happy, and free.

For the next five years Hensel was in Rome, but he and Fanny kept in touch with each other through the letters Hensel and Lea exchanged.

Hensel did not live under the same restrictions that Fanny did. He could express his emotions freely. From Rome, he wrote to his sister Luise about his affection for Fanny. "I have decided to confide in you and acquaint you fully with what is in my heart . . . I had previously intended to do so in a verbal conversation . . . I do not, however, wish to keep a secret from you until I return—and so here it is: I am in love."

In July 1821, Fanny received a letter from her father that explained Carl Friedrich Zelter's change of attitude about her as a composer. Abraham, who was in Paris on another extended business trip, wrote that, "What you wrote to me about your musical occupations with reference to and in comparison with Felix was both rightly thought and expressed. Music will perhaps become his profession, whilst for *you* it can and must only be an ornament, never the root of your being and doing."

In other words, Abraham was saying that his daughter could never become a professional composer. All she could

hope for was to compose songs for her own enjoyment and to entertain friends and family.

Even for her brother Felix there were doubts about a musical career. Members of the upper class did not usually work in professions open to members of the lower classes. When the matter was brought to Jacob Bartholdy's attention, Lea's brother wrote back to his sister and brother-in-law. "The idea of a professional musician will not go down with me. It is no career, no life, no aim . . . Let the boy go through a regular course of schooling, and then prepare for a state career by studying law . . . Should you prefer him to be a merchant, let him enter a counting-house early."

Felix Mendelssohn, Fanny's brother, as a young boy

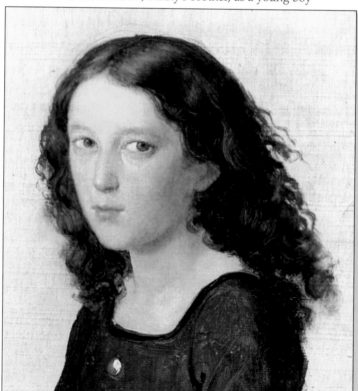

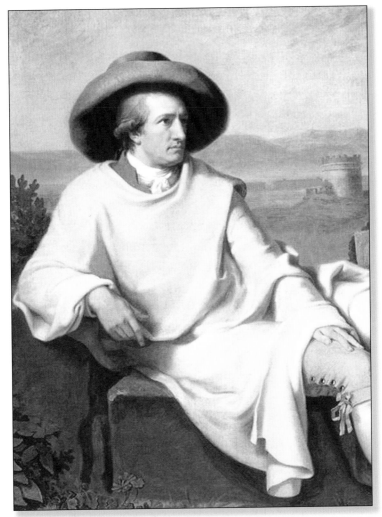

Fanny was forced to live vicariously through her brother as he visited Wolfgang von Goethe *(above)*, a famous German poet and philosopher.

Despite the family's misgivings about a musical career, Zelter convinced the Mendelssohns to allow him to take Felix to visit Johann Wolfgang von Goethe in Weimar, Germany. They would get Goethe's opinion on whether Felix had the talent to be successful as a musician. In October 1821, Felix and Zelter traveled by coach to Weimar. Fanny remained in

Berlin with the rest of her family. This was the first time she and Felix had been apart and she felt lost without her brother. Her music suffered because she could not compose when Felix was not nearby. She wrote to her brother, "I miss you from morning till night . . . and the music especially will not flow without you."

Toward the end of October, Fanny developed a cough and wrote to Felix about her illness. "This unwelcome guest has so tormented me for several days that I feel the victim of a violent aggression and cannot do much of anything at all. Just imagine, I haven't played the piano for three days."

A few days later, Felix sent Fanny the music for an opera he was working on. Because of her cough she could not sing the music or give him her assessment until she was well. She could not go to the Singakademie, but she promised Felix, "This week I still have to miss the Academy, but in a week no doctor will be able to keep me at home."

Ever the older sister and teacher to her younger brother, she often addressed him as *dear son* or *dear little one* in her letters. In one letter she sounded very much like her father when she criticized how Felix wrote his letters:

> First of all, dear little fellow, you should have consulted the calendar you took out before your departure, and then you would have discovered that there has never been a 32 October, the date given at the end of your letter. Second, one puts the place on the right when beginning a letter, whereas until now you've been writing it on the left. These remarks are unimportant in themselves, you won't take them badly since your know they're kindly meant.

Fanny also instructed Felix on how to behave around Goethe. He should listen to everything the poet said and report it to her so she could know every detail. There was no such thing as too many details. She wanted to know everything that Goethe said, what music Felix played for him, and how Goethe reacted. She also asked Felix to send her a sketch of Goethe's house.

To hear about Felix's activities was her way of being on the trip with him. She would continue to live vicariously through Felix for the rest of her life, as his musical career flourished and he traveled through Europe giving concerts to ever larger audiences.

Even though Fanny was proud of Felix, she was also envious and her letters occasionally reflected it. Should Goethe make a positive judgment on Felix's talent he would then begin a career as a professional musician. But she had to stay home.

Felix took some of the music he had composed with him to Weimar. He also took several of the songs that Fanny had composed, including one called "Erste Verlust" (First Sorrow). Felix wrote Fanny, "Early yesterday I showed your songs to Frau (Misses) von Goethe, who has a pretty voice. She is going to sing them for the old gentleman. I also told him already that you wrote them and asked him if he would like to hear them. He said yes, yes, very much." Felix added that Mrs. Goethe was especially fond of her songs, which he thought was a good omen.

Goethe listened to the music that both Fanny and Felix had composed. Afterward, he said that Felix clearly had enough talent to make music his career—and that Fanny was equally as talented as her brother.

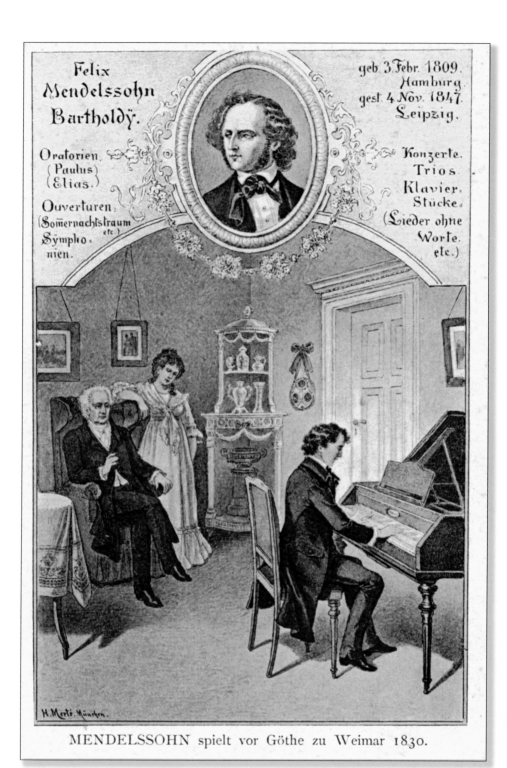

This sketch shows Felix performing for Wolfgang von Goethe. (*Courtesy of Lebrecht Music and Arts*)

Before Felix and Zelter returned home to Berlin, Goethe gave Zelter a poem he had written entitled "To a Distant Girl" and asked Zelter to deliver it to Fanny.

Even the praise of the great Goethe was not powerful enough to break the rigid social system, however. Fanny's father had told her she could never become a professional composer, and he was firm about that. The only career open to her was that of a wife and mother—and Fanny knew that she would have to obey her father.

three

Journey to Switzerland

Despite the lack of encouragement, Fanny continued to compose music. Mostly, she wrote songs and piano pieces that she played for family, friends, and visitors.

The year 1822 was particularly productive. In January she wrote a movement for a piano sonata in E major and in November she composed her first chamber work for double bass, two cellos, and a violin. She called it *Die frehen Graber* (The Early Graves). She also wrote at least ten songs in 1822.

It was also a momentous year for the rest of the Mendelssohn family. Lea bore another child the previous year, but the baby died at birth. When Lea became depressed, Abraham made arrangements for a journey to Switzerland in the hope that a trip would help his wife overcome her depression. Because he knew Lea did not like to leave home, Abraham

convinced her that the journey would benefit their children's education.

Lea, Abraham, and their four children set out for Switzerland by coach on July 6, accompanied by the children's tutor Karl Heyse and several servants. It was an exciting adventure from the beginning. On the first day of the journey, as the coaches traveled from Berlin to Brandenburg, they realized Felix was missing. Heyse turned around and backtracked and found Felix in Potsdam, about three miles back. Fortunately, Felix did not seem the least bit upset that the family had inadvertently left him behind.

In Frankfurt, Lea's cousins Julie and Marianne Saaling joined them. Fanny enjoyed the company of the two sisters, although they were considerably older. Julie was thirty-five and her sister a year older. Fanny wrote, "We laugh incessantly and especially in the evening, before going to sleep (I always sleep with them), they are absolutely unique. Marianne knows people everywhere and wherever she goes is greeted with delight."

Although she was enjoying the journey, Fanny was a little envious of the more outgoing Marianne Saaling. Making light-hearted conversation was not easy for her. She could not tell funny stories and jokes the way Marianne could. She was far too serious.

These feelings of self-doubt were new. Fanny had grown up in a loving household where her accomplishments were praised. Now, her uncertainties worried her so much that she mentioned it when she wrote to her aunt Henriette in Paris.

Henriette Mendelssohn wrote back:

How grateful you must be to your dear mother for agreeing to this journey, and how loving you must be

to your father for having organized it. Be happy and contented, therefore, and if you cannot manage to be really funny, console yourself with this remark of Goethe's: 'Life also needs somber-colored leaves in its wreath.' Enjoy it fully, and be happy and free of problems, without worrying too much whether you are living life as you should.

The family was invited to a concert at the Frankfurt home of Aloys Schmitt, a German composer who had visited the Mendelssohns in Berlin. Fanny was disappointed in the musical presentations. She did not care for the violinist who opened the concert; both she and Felix found his playing soft and without power. She also did not care for the way one of Felix's compositions was played.

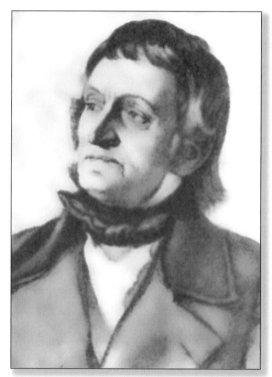

Fanny was also asked to play something, which made her nervous. At home, she played mostly for family and friends. This

During their vacation, the Mendelssohns visited the home of German composer Aloys Schmitt. It was here that Fanny first performed in front of strangers instead of family and friends.

room was full of strangers—pupils and friends of Aloys Schmitt—when she played. Later, she felt she did not play well and that the musicians who accompanied her were not very capable. She said, "My failure was such that I could have beaten myself, and all the others, with vexation." Throughout her life, Fanny set high standards for herself musically and expected others to do the same. When either she or others did not meet those standards, she was displeased with herself or them.

The caravan of coaches continued southward from Frankfurt, through the city of Stuttgart into southern Germany before crossing into Switzerland. Fanny described the Reuss River valley as "very broad and fertile." Walnut, fruit, and evergreen trees grew in this valley, and high rocks rose up on either side of the road. They headed higher into the mountains, past glaciers and snow-capped peaks. Ahead, Fanny could see the Alps, the largest mountain range in Europe. The Alps extend across Switzerland between Germany and Italy and also form the border between France and Italy.

Fanny wrote to her cousin and dearest friend Marianne:

> I have spent a day, dear Marianne, the memory of which will never be extinguished in my heart, but will influence me all my life. I have seen God's grand nature, my heart has trembled with emotion and veneration (deep respect), and when my excitement had subsided and I beheld what mankind considers most beautiful and lovely, when I stood on the borders of Italy, then my fate decrees, Thus far, but no farther. Never, never have I felt such a sensation!

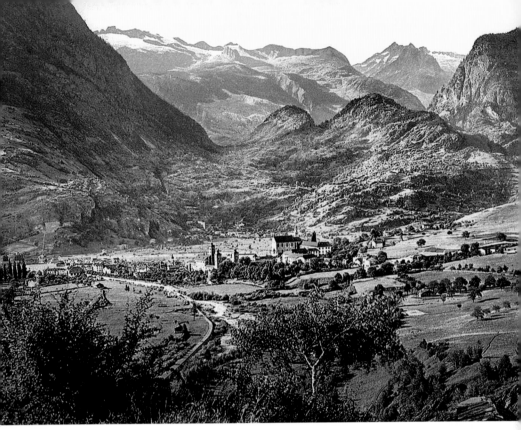

Fanny was inspired by the spectacular views she saw while vacationing in the Swiss Alps with her family. *(Library of Congress)*

But she knew it was improper for a young woman to walk outdoors without being accompanied by a chaperone. It would be many years before she would visit Italy. To console herself, she composed a song based on Goethe's poem, "Sehnsucht nach Italien" (Yearning for Italy.)

As the caravan turned north, the Mendelssohns stopped in Interlaken. There Fanny wrote long letters to Marianne describing in great detail everything she had seen and the emotions she had felt.

In Interlaken, Fanny and her brothers, sister, and cousins, spent hours walking the mountain trails. When the paths became too steep and rocky for walking, they rode horses. During one trip, Fanny noticed a passage cut through the rocks. On the far side, was a sight that took her breath away—a valley

far below her with meadows surrounded by low hills, houses and church steeples.

Fanny was deeply impressed by the natural beauty and wrote to Marianne: "The cutting wind, which towards evening blows here and is called the glacier-wind, the snowy peaks here and there standing forth, the twilight beginning to prevail in this 'mountain valley,' and every other surrounding feature, contributed to increase the feeling of awe."

Once the procession had crossed the border back into Germany, the Mendelssohns stopped in Weimar to meet

This Robert Poetzelberger painting shows Fanny and Felix together at the piano. *(Courtesy of Bettmann/Corbis)*

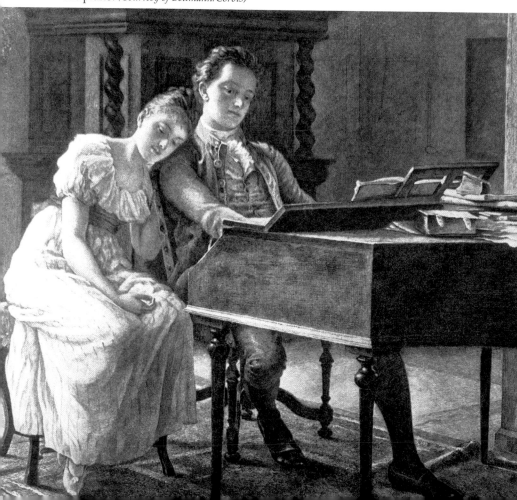

the Goethe family, who had been so hospitable to Felix the previous year. Goethe asked Felix to play the piano for him. Afterwards, he squeezed Lea's hand, told her that her son was a charming and delightful boy, and invited Felix to visit him again soon.

Fanny was also asked to play the piano for Goethe. She played some of her own piano pieces, including the songs she had composed from Goethe's poems. Goethe was pleased that Fanny had set his poems to music and asked her to play the music of Bach for him.

When the Mendelssohns returned to Berlin in October, both Fanny and Felix continued to compose. Felix shared his ideas for all his compositions with his older sister, telling her what he intended to write before he set pen to paper. Fanny's love for her brother was so deep that she made it her priority to further his budding career. She wrote about Felix: "I have watched his progress step by step, and may I say I have contributed to his development. I have always been his only musical adviser and he never writes down a thought before submitting it to my judgment. I have known his operas by heart before a note was written."

As Fanny listened to Felix's compositions as he worked on them, she made a polite little coughing sound to indicate when she did not like a particular part. Felix then went back to the piano and reworked the parts she did not like.

Soon after their return from Switzerland, Abraham and Lea converted to Lutheranism while on a trip to Frankfurt. They also adopted the Bartholdy name their children had taken. Shortly after the conversion, Abraham gave up his interests in the banking business to devote his time to his children's education—especially Felix's.

Portrait of Rebekka (left) and Fanny (right) drawn by Wilhelm Hensel
(Courtesy of Lebrecht Music and Arts)

The Mendelssohn bank continued on without Abraham. When he was old enough, Paul Mendelssohn joined the business. Paul had received the same musical education as his siblings, but while he became a capable cellist, music remained only an enjoyable hobby to him. Unlike Fanny and Felix, he was not a musical prodigy.

Rebekka received the same initial musical education. It had been a long tradition in the Itzig family for women to receive musical training as part of their general education. Lea's aunt Sara Levy was a talented harpsichordist who had studied music with Wilhelm Friedemann Bach, Johann Sebastian Bach's oldest son. She was also a patron to Bach's youngest son, Carl Philipp Emanuel, and supported him financially while he studied law. Fanny Arnstein, another of Lea's aunts, moved to Vienna, Austria, after her marriage, where she gave musicales in her home, becoming one of Vienna's most famous *salonistas* (women who gave salons or musicales).

While Rebekka was not as musically talented as her two oldest siblings, she had a lovely singing voice and learned languages easily. About her musical talent, Rebekka later said, "My older siblings stole my artistic fame. In any other family, I would have been much praised as a musician and perhaps even have directed a small circle. But next to Felix and Fanny, I could not have succeeded in attaining any such recognition."

In December 1822, Wilhelm Hensel returned to Berlin for a visit. He brought Fanny a collection of poems written by his friend Wilhelm Muller. Hensel added a poem he himself had written and titled "To Fanny" and a self-portrait to the collection. Lea thought the portrait was an inappropriate gift. When Hensel left the Mendelssohn home, she sent him a letter:

> I did not want to spoil yesterday evening's enjoyment by observing to you that I find it improper for a young man to offer his portrait to a young girl, in whatever form

it may take. . . . I am returning your friend's poems so that Fanny may again receive them from you, freely and with pleasure, once the accompanying adornment (the self-portrait) has been removed.

To build on the prestige that came with Goethe's positive comments about Felix's talent, Abraham and Lea began to give musicales in their home. This gave Felix an opportunity to play his compositions on a regular basis for an audience of influential people. Fanny also had a chance to play her own compositions.

As successful as the musicales were, Abraham and Lea began preparing the next step in Felix's budding career, and it would change the life of the family and Felix's relationship with his beloved sister.

Separation

A year after the Mendelssohns returned to Berlin from Switzerland, Abraham, accompanied by Felix and Paul, set off on a trip to Selesia, a region in the eastern part of Germany near the Oder Mountains. After the praise Goethe had heaped on Felix, Abraham hoped to get similar opinions on his eldest son's talent from some prominent composers.

Fanny and Rebekka remained in Berlin with their mother. Fanny continued to perform the duties of a young woman who was expected to marry and run a household, but she continued to compose. By 1824, she had completed her thirty-second fugue, which is a musical conversation among various instrumental voices on a single theme.

When the travelers returned home, Abraham and Lea decided to give their musicales on alternate Sundays. Doing so would give their children, especially Felix, an opportunity

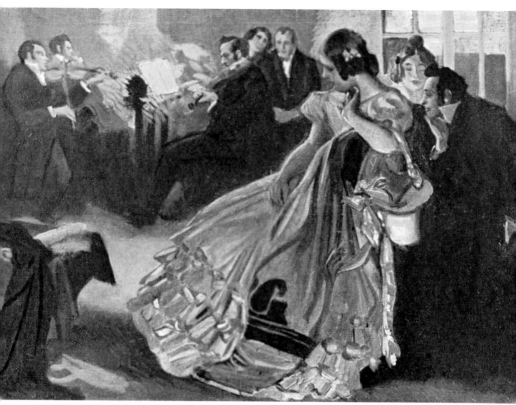

The Mendelssohn home in Berlin became the stage for regular musicales, which often incorporated string quartets and orchestras. *(Courtesy of Lebrecht Music and Arts)*

to perform in front of an audience on a regular basis. Lea sent out personal, handwritten invitations to a small circle of friends and families. She served an elaborate luncheon, and all four of her children performed. Fanny played some of her piano pieces as well as some of Felix's compositions. Rebekka sang and Paul played the cello.

Felix was the featured performer, playing his own musical compositions. Sometimes Abraham hired a small orchestra, sometimes a chorus, and sometimes both for each performance, depending on the requirements of the music. Fourteen-year-old Felix decided on the program, was in charge of the rehearsals prior to the performance, conducted the orchestra, and was the piano soloist.

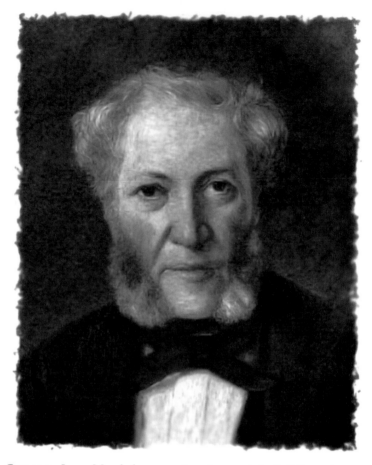

Composer Ignaz Moscheles gave piano lessons to both Felix and Fanny while he was in Berlin. He later described Fanny as "infinitely talented."

As time went on, the reputation of Lea's Sunday musicales spread. Distinguished musicians passing through Berlin asked to be invited. Receiving an invitation was a privi lege—the Mendelssohn house on New Promenade was not large, and the size of the audience had to remain small.

When Abraham took his family on vacation to a Baltic Sea resort that summer, Fanny and Felix went for a walk together. They were confronted by a group of boys who threw rocks at them and taunted their Jewish features. This was Fanny's first personal experience with anti-Semitism.

In the fall of 1824, Lea Mendelssohn became aware that the composer Ignaz Moscheles was in Berlin on a concert tour. She wrote to him asking him to give Fanny and Felix some piano lessons while he was in Berlin. Moscheles agreed. On November 28, he visited the Mendelssohn home during one of the Sunday musicales and heard both Fanny and Felix play. On December 3, he attended one of the Friday musicales at Carl Friedrich Zelter's house, where Fanny played Johann Sebastian Bach's *Concerto in D Minor*.

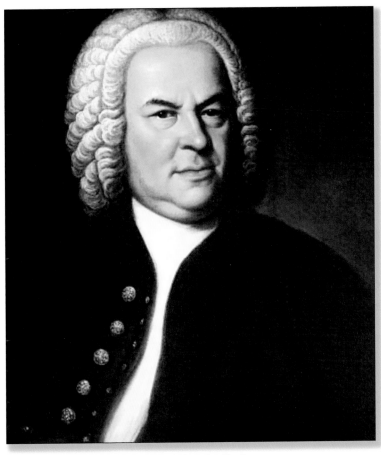

Johann Sebastian Bach

After meeting Fanny and Felix he wrote:

> This Felix Mendelssohn is already a mature artist, and he is only fifteen! His elder sister, Fanny, who is also infinitely talented, plays fugues and passacaglias (continuous variations of basic themes played in the low notes) by Bach from memory and with admirable precision; I think she may justifiably be termed 'a good musician.'

In 1825, Abraham Mendelssohn moved his family to a property he bought at Number 3 Leipzigerstrasse (Leipzig Street). The new home was a large house set on ten acres of land in an area near the Potsdam Gate. Abraham felt that his family would not experience so much anti-Semitism away

A sketch of the Mendelssohn home at Number 3 Leipzigerstrasse by Wilhelm Hensel *(Courtesy of Bildarchiv Preussischer Kulturbesitz/Art Resource)*

from the center of Berlin. Besides the main house, there were gardens as vast as parks, and a garden house with a huge hall where several hundred people could sit.

The house was in disrepair and while Abraham traveled to Dobberan, a town in Germany near the shore of the Baltic Sea, Lea saw to its renovation. She happily described the house to her cousin Henriette Pereira, "A whole row of rooms opens onto the garden, which is itself surrounded by other gardens . . . nevertheless, one is just a few yards from the most elegant and lively streets of Berlin, and able to take advantage of all the comforts of city life."

She went on to tell her cousin about the garden house. At its center was a very large room where the Mendelssohn children could perform for larger audiences at their Sunday musicales. Four steps lead down from the garden house to the garden, with its many paths and groups of trees leading away as far as the eye could see.

Besides renovating the interior of the house, Lea improved the garden, which had a view out over the city, planting lime, chestnut, elm, and beech trees, and acacia bushes. In order to keep the trees and shrubbery from ruining the view, Lea decided to cut a few down.

The Mendelssohns rented out a part of one of the floors in the house to Karl Klingemann, a German poet who would remain friendly with both Fanny and Felix for many years.

In the early spring of that year, Felix made another trip to Paris with his father. This time he and Abraham traveled there to bring Henriette Mendelssohn home to Berlin. She'd been a governess in Paris. The girl she had taken care of for many years, Fanny Sebastiani, was now married and Henriette's services were no longer needed.

Abraham had another reason for taking Felix to Paris. He wanted to expose him to other musicians and to get their opinions of Felix's talent. Felix was introduced to Luigi Cherubini, an Italian-born composer who headed the Paris Conservatoire, one of the foremost music schools in Europe. Felix played his *Piano Quartet in B Minor* for him. Afterwards, Cherubini wrote, "This boy . . . will do well; he is already doing well."

Felix also met the composer Anton Reicha, who was also impressed with the young man's musical talent. Meeting these well-known composers gave Abraham the assurance he needed that Felix was, indeed, a gifted composer and musician and was ready to begin his professional career.

Just as she had when Felix and Zelter visited Goethe in 1821, Fanny urged Felix to write to her about the people he met in Paris. She wanted to know about everything he saw and heard, so she could feel as if she were in Paris with him. Felix wrote regularly. He complained that the music scene in Paris was inferior to Berlin. The musicians he met were not as educated or knowledgeable about music. For example, they either were not familiar with Johann Sebastian Bach or did not appreciate his music. Both Felix and Fanny had grown up with Bach's music and Felix could not understand why the musicians he met did not play it.

Fanny scolded him for not appreciating his good fortune. After all, he was in Paris, while she had to stay at home, and he had the nerve to complain and criticize the musicians that he met. She also scolded him for writing that he hadn't heard any decent music in Paris. "You go to Paris and you don't hear a single decent note, at least not very many; and those of us who've stayed quietly at home are drowning in music.

. . . I hope that memory will put pink clothes on everything your prejudices are now covering with gray dust; if everything you see were really as bad as that, it would be a pity to have gone on such a journey."

Fanny complained that Felix was not living up to his responsibilities when it came to describing the other things that he saw and did in Paris. She knew all about the cultural activities that were available in Paris from the year the Mendelssohns had spent there. She knew that he'd visit museums where he'd see beautiful paintings, tour public gardens, and see the striking architecture of the buildings in the city. She wanted to hear about all of those things, so she would feel as if she were there with him. Yet, all he did was complain.

Her letters also kept Felix up-to-date on what was going on at Number 3 Leipzigerstrasser. Karl Klingemann, the Mendelssohns' tenant, had become an active member of their family.

> On Sunday afternoon we were in our garden . . . We all crouched along the ground and looked for violets, including Klingemann, who made fun of us. In addition, he put on his glasses and then lowered himself on a chopped-off tree trunk to arrange the flowers, earth, and grass gathered in his handkerchief. Can you actually picture this grandiose figure? Our garden is already splendid; how wonderful it will be in May, when the lilacs will be blooming.

Fanny also wrote Felix that his composition, *Pastoral*, was performed for the first time in their new large garden hall with its vaulted ceiling. A conductor and orchestra had been

This painting depicts Shakespeare's *A Midsummer Night's Dream*.

hired. Approximately two weeks later it was performed again, this time with a different conductor. Fanny told Felix that his composition had "clarity and truth, richness and unity from start to finish. . . . The piece possesses infinite charm, and displays the grace of the instruments more effectively than any other piece I know."

That summer, the four Mendelssohn children put on a performance of Shakespeare's *A Midsummer Night's Dream* in the garden. It was the perfect setting for the play, which was set in an enchanted forest. The play had recently been translated into German and all the Mendelssohn children were enthusiastic about playing their roles. They were

seasoned performers who felt comfortable on stage in front of an audience.

The children also began to write a newspaper they called *Garden Times.* They put whatever ideas came into their minds in the paper, including jokes, music, and poems. When winter came they changed its name to *Tea and Snow Times.*

The children enjoyed the garden, finding creative inspiration in its beauty. Felix composed his *Octet in E Flat,* which he wrote to play in an upcoming Sunday musicale in his home, in the garden. It was an extraordinary composition for such a young person and established Felix as a major composer. Fanny bragged, "To me alone he told his idea."

By 1826, the Mendelssohns' new home had become the place where cultured Berliners and visitors to that city gathered for the Sunday musicales. Lea and Abraham were pleased that those gatherings afforded their children the opportunity to showcase their individual and collective talents.

In 1826, Felix composed *A Midsummer Night's Dream Overture* to play at one of the Sunday musicales. He composed a separate version of the *Overture* for two pianos, so he and Fanny could play it together.

That fall, Ignaz Moscheles returned to Berlin on another concert tour. He attended one of the Sunday musicales and Fanny and Felix played the four-handed version of *A Midsummer Night's Dream Overture.* The *Overture* created a sensation and Felix was invited to perform it in other places. Fanny was not included in the invitation; that would be considered inappropriate.

Felix traveled to Stettin, Germany, a port city northeast of Berlin at the northern end of the Oder River. On February 20, 1827, he conducted *A Midsummer Night's Dream Overture.*

It was a smashing success. Felix was now a professional composer and conductor. He began to publish his music. He no longer took lessons from Carl Friederich Zelter and also quit the Singakademie. Only Fanny remained there.

On April 29, 1827, Felix's opera, *The Wedding of Camacho*, was presented at the Berlin Opera House. It was based on a part of Cervantes' *Don Quixote*, which had recently been translated into German. A distinguished audience, including people who regularly attended the Mendelssohns' Sunday musicales attended, along with family and friends. However, the opera was not successful and the remaining performances were canceled. Felix became so depressed at the negative reaction to *The Wedding of Camacho* that he never completed another opera.

That fall, Karl Klingemann moved to London. Once he was settled in, Fanny wrote to him about her birthday party, which she celebrated on November 11 with a dance attended by female friends and family members. She told Klingemann that, as a birthday gift, Felix had composed a piece for chorus and orchestra that she believed was remarkable and should be played in a church to be fully appreciated. She summarized her brother's recent work: "Altogether he has devoted himself much to church music of late."

Fanny wrote to Klingemann again on Christmas Day 1827, describing Christmas at home: "The Christmas-candles are burnt down, the beautiful presents stowed away, and we spend our Christmas day quietly at home. Mother is asleep in one corner of the sofa, Paul in the other, Rebekka absorbed in the Fashions."

Her letter went on to describe some of the presents she and Rebekka had received from Felix. The children's symphony Felix had composed for sixteen-year-old Rebekka was

amusing. For her, Felix had composed a beautiful four-part piece for chorus and small orchestra, which he called *Christ, Lamb of God*.

In late 1827, Fanny attended a group of lectures on physical geography given at the Singakademie by Alexander Humboldt, a German naturalist and explorer. She found the lectures to be very interesting. She wrote to Klingemann about the lectures, which were attended mostly by women, "Gentlemen may laugh as much as they like, but it is delightful that we too have the opportunity given us of listening to clever men."

Soon afterwards, Fanny attended a series of lectures on experimental physics. One of the things she found exciting about *those* lectures was that the room in which they were held was lit by gas lamps, which enabled her to see everyone in the room at the same time. This was unusual because, in 1827, most rooms were lighted by candles.

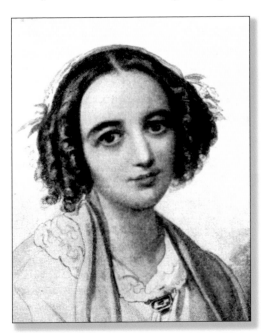

For the first time, in 1827, three of Fanny's songs were published. *Das Heimweh* (Home-sickness), was filled with longing for home, *Italien* (Italy), was about the beauty of nature in general and of Italy in particular, and a duet

Portrait of Fanny as a young woman (*Courtesy of Lebrecht Music and Arts*)

called *Suleika und Hatem* (Suleika and Hatem), was a song about the love of a man and a woman. All the pieces were set to poems written by German poets.

Although Fanny wrote the music, the songs were published under Felix's name and included in his first volume of published songs. It would take three years before another three of her songs would be published. The next group—published in 1830—were titled *Sehnsucht* (Desire), a song that expresses the singer's longing for love, *Verlust* (Loss), which describes how it feels to lose someone, and *Die Nonne* (The Nun), about a nun's religious feelings. These, too, were published under Felix's name in his second volume of published songs. It would not have been proper for Fanny to have them published under her own name.

Fanny's songs, typical of many written in the Romantic tradition, were full of passionate feelings of love, loss of love, and longing for a lost love, and the music reflected those feelings.

On Fanny's twenty-third birthday, in 1828, Abraham sent her one more letter on a subject he had discussed many times before. "You must become more steady and collected, and prepare more earnestly and eagerly for your real calling, the *only* calling of a young woman—I mean the state of a housewife," he wrote.

Fanny accepted her father's advice without a murmur of opposition or a hint of disobedience. A month earlier, Wilhelm Hensel had returned from Rome.

Marriage

W ilhelm Hensel's return to Berlin in 1828 changed Fanny's life. There were other changes in the Mendelssohn household. Felix planned to leave Berlin for London in April to begin his career as a composer and orchestra conductor. Paul was about to start his career as a banker. Only Fanny, at age twenty-four, and her sister, now eighteen, would remain at home. "This year will bring about a major break in our family life," Fanny wrote. "Felix, our very soul, is going away; the second half of my own life awaits me. Paul is going into the world: everything is in a state of movement and change at home, just as it is among most of our acquaintances and in the world. I'm going back to 3 Leipziger Strasse."

On January 22, 1829, Fanny and Wilhelm Hensel's engagement was announced. Abraham and Lea had a marriage contract drawn up that specified Fanny could not spend large

The Berlin Singakademie *(Courtesy of Lebrecht Music and Arts)*

amounts of her money without Abraham's permission. Even though she was an adult and would be a married woman, her father still had control over her money.

Before Felix left Berlin, he gave his final performances at the Singakademie. He chose Bach's *St. Matthew's Passion*. At the time, Bach's music was still relatively unknown outside musical circles. The performance electrified the audience and the concert attracted so much attention the Singakademie sold out shortly after the tickets went on sale. Felix rehearsed the orchestra and the chorus, in which Fanny sang alto. She described the scene at the Singakademie on the day of the concert. "As soon as the doors were opened, the people, who already had been waiting outside, rushed into the hall, which was quite full in less than a quarter of an hour."

While Fanny was happy because of her engagement to Wilhelm Hensel, she was sad that Felix was about to leave for England. All that she would have left of him was a portrait that Wilhelm had painted. She described the portrait to Karl Klingemann:

> A beautiful keepsake we have of him, his portrait by Hensel, three-quarter life-size, the likeness perfect—a truly delightful, amiable picture. He is sitting on a garden bench (the background formed by lilac-bushes in our garden), the right arm reposing on the back of the bench, the left on his knees, with uplifted fingers. The expression of his face and the movement of his hands show that he is composing.

On April 10, Fanny saw her brother off on his four-month long trip to London. Abraham and Rebekka traveled with him as far as Hamburg and returned to Berlin two weeks later. Felix made the remainder of the journey alone and went first to the London home of Karl Klingemann. He sent home letters that talked glowingly about the city and of his concerts, which were enormously successful. But when people from the audience came up to speak to him after his concerts and told him how much they admired his piano playing he was heard to remark, "But you should hear my sister Fanny!"

Fanny read all of Felix's letters, memorizing their details so she would feel as though she herself were in London. She believed that her brother was enormously talented and, even before he left Berlin, knew he would have a successful career. She wrote to him later, "I never doubted your success. The news of it hasn't surprised me, but has nevertheless put me in a pleasant and lighthearted mood."

She said the same thing to Klingemann in a letter written the following day, "You will not misunderstand me when I tell you that Felix's success has neither surprised, dazzled, nor confounded me, and that altogether as regards him I have an almost silly belief in predestination."

Late spring and early summer of 1829 was rainy in Berlin, which kept Fanny indoors a great deal of the time. She received friends and relatives at home, gave luncheons and dinner parties, and, prepared for, rehearsed, and performed in the Sunday musicales. She also wrote regularly to Felix and kept him abreast of everything that was going on at home. She told him about her visits to the Singakademie, where Carl Friedrich Zelter had the *St. Matthew's Passion* performed again. She assured Felix that those performances were inferior to his. She also sent him news and gossip about the people who visited at Number 3 Leipzigerstrasser. Above all, she told him how much she missed him and wanted to hear that he was happy. "Once again I need your assurance that you're happy. Sometimes it's as necessary to me as air is to life, and then it will tide me over for a while."

By early June, she had made copies of six of her songs and sent them to Felix. She was eager to get his reaction and wrote, "Please give them a critical evaluation. One is among them that I consider one of my best, and we shall see if you feel the same way." With Felix's departure from home and the beginning of his career as a professional musician, the musical relationship between brother and sister changed somewhat. She now was more dependent on Felix's approval. Since childhood, they had always examined each other's compositions and offered suggestions. Now, Felix was worldlier, performing in front of larger audiences and

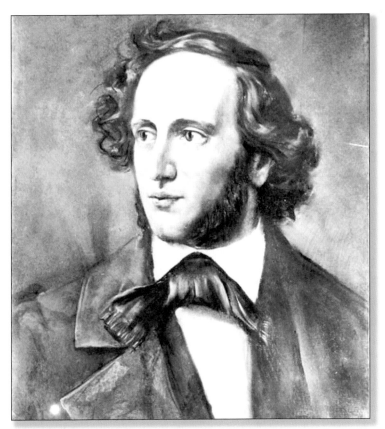

Felix began to drift away from Fanny as he gained notoriety for his compositions and traveled the world while she stayed in Berlin to fulfill her role as a dutiful wife. *(Library of Congress)*

moving in the company of prominent musicians. While the siblings continued to discuss their works, especially through their letters to each other, the discussions lacked the intensity of earlier communications.

By the middle of June, the weather had warmed and Fanny sat outdoors to write letters and to compose music. She began a piece for the processional down the aisle at her wedding. Wilhelm also sat out in the garden and worked on family portraits he painted from sketches he had made earlier–including another portrait of Felix.

Fanny also set to music a poem Wilhelm had written as a birthday present. She also planned the celebration of Abraham and Lea's silver wedding anniversary, which would take place in December. In their letters, Fanny and Felix exchanged ideas for the upcoming celebration and the musical pieces each wanted to compose for the occasion.

On September 6, Fanny and Wilhelm's wedding date was announced. It would take place on October 3. Immediately after the announcement, Fanny and her mother immersed themselves in wedding preparations. "We are very busy at present, and pass our mornings mostly in the shops, and I cannot enough admire my indefatigable mother . . . I find it almost impossible to tell her how grateful I feel, or else I must do nothing all day long but thank her," she wrote to her father, who was traveling to Hamburg and then to Holland, where he planned to meet Felix.

Abraham sent home a box containing ribbons, a shawl, and a veil as a wedding present. Fanny was delighted with the presents, telling her father, "Again you have brilliantly displayed your taste and your munificence: everything is the most beautiful of its kind that I have ever seen, the embroideries, materials, and patterns all perfect." She speculated about the impact of the veil, an unusual part of a bride's wedding clothing at the time.

> The beautiful veil has created a great sensation in the female minds, and gives us much agitation, veils not being the fashion here for brides. But I like a veil, and think it is so beautiful and fit for the occasion, and it would be especially suitable for me on account of my red neck. Therefore I have the greatest mind to wear it and be the first—sure enough not to be the last.

On September 17, Felix was in a carriage accident in London. He injured his knee severely and had to remain in bed. He had planned to travel from London to Holland, to meet his father. From there, they would return to Berlin in time for Fanny's wedding. Felix had to change his plans and delay his return to Berlin.

Felix had promised to compose a piece of music to play at the wedding. But, because of his injury, he was forced to tell Fanny he could not fulfill his promise to her. He sent her his best wishes because he would not be able to convey them to her in person.

> This then is the last letter that will reach you before the wedding, and for the last time I address you as Miss Fanny Mendelssohn Bartholdy. . . . Live and prosper, get married and be happy, shape your household so that I shall find you in a beautiful home when I come (that will not be long), and remain yourselves, you two, whatever storms may rage outside.

In the days preceding her wedding, Fanny was busy with fittings but managed to complete the music she had been composing. On October 2, the day before the ceremony, she ran errands and saw to last-minute details and went to the church to listen to a rehearsal of the organ piece she had written. Then she realized there would be no music for the recessional part of the ceremony. The bridal party would have to walk back up the aisle to the back of the church at the completion of the ceremony with no music to accompany them. Wilhelm suggested that Fanny compose a new piece and, in spite of all the relatives who had come to the

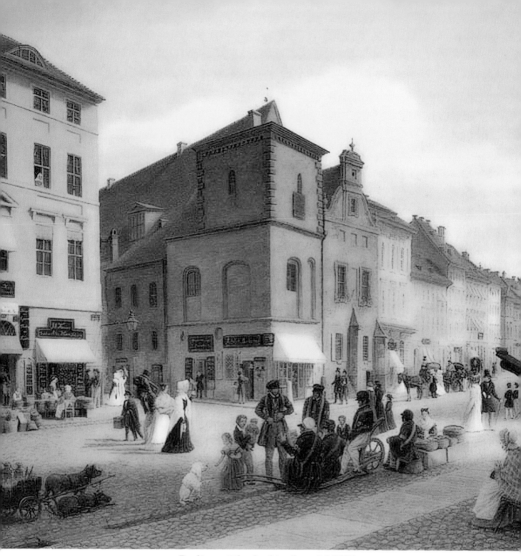

Berlin as it looked in the mid-1800s.

Mendelssohn home and had to be attended to, she composed a final piece of music for her wedding.

In the afternoon of October 3, 1829, Fanny and Wilhelm were married. She was a happy bride. All of her friends and family were in attendance. The only dark shadow was the absence of Felix. He did not return to Berlin until December.

After her marriage, some things remained the same. As they did every year, the Mendelssohns celebrated Christmas.

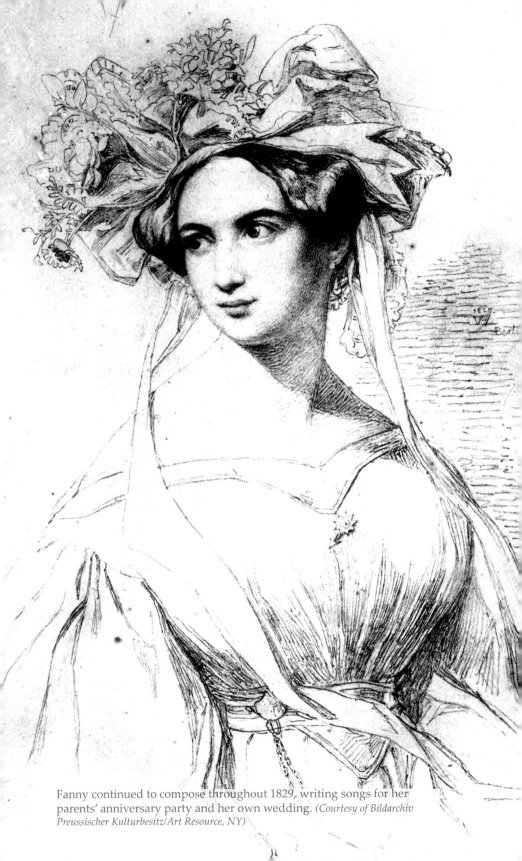

Fanny continued to compose throughout 1829, writing songs for her parents' anniversary party and her own wedding. *(Courtesy of Bildarchiv Preussischer Kulturbesitz/Art Resource, NY)*

On the morning of Christmas Eve, Fanny and her family distributed warm clothing to less-fortunate Berliners and that evening exchanged Christmas gifts. On Christmas Day, their friends and family members, including some of Lea's relatives, visited the Mendelssohn home and more gifts were exchanged.

On December 26, 1829, Lea and Abraham Mendelssohn celebrated their silver wedding anniversary, commemorating twenty-five years of marriage. Felix had brought home from London a musical play as a gift for his parents. He had composed the music and Karl Klingemann had written the libretto (words). They called their collaboration *The Return from Abroad*. It was performed in the Mendelssohn home in front of 120 family members and friends. An orchestra was hired and Paul played the cello. He had a solo part, which Felix had written for him.

Fanny also composed a piece as an anniversary gift for her parents. It featured three singers, each of whom represented an important wedding anniversary in Lea and Abraham's lives. Therese Devrient, who, with her husband rented an apartment in the Mendelssohn home, was one of the singers; Fanny and Rebekka were the other soloists.

Lea later described the costumes the singers wore while performing Fanny's music to Klingemann, who did not attend the performance:

> Therese, crowned with roses, symbolized the first wedding; Rebekka—whose dress and veil were richly embroidered with diamonds and who wore myrtle (a plant with evergreen leaves, white or pink flowers, and fragrant berries) in her hair—the silver wedding; and Fanny, who

was adorned in the same manner, but entirely in gold, represented the golden wedding (to celebrate fifty years of marriage in the future); all three were pleasing to look at and made a truly touching impression.

Lea's letter went on to describe how her daughters looked as they performed in the musical play Klingemann and Felix had written: "They wore quite different costumes for your light musical, in particular bonnets of black velvet decorated with gold. Fanny and Rebekka were more spontaneous and confident than I would ever have thought them capable of being."

The celebration of her parents' silver wedding anniversary was a success. The year 1829 had ended well. Fanny had married Hensel, Felix was home again, and she looked forward to the trip to Italy that her husband had planned. She had yearned to see Italy since the Mendelssohns had gone to Switzerland in 1822 and Fanny had looked over the mountains into Italy. But Fanny's dream of seeing Italy was not to be fulfilled at that time.

Motherhood

Wilhelm Hensel knew how much Fanny wanted to visit Italy. He had lived in Rome for five years and knew the country well and was eager to take his wife there. He and Felix made plans for the entire Mendelssohn family to make the journey from Berlin together. They would meet Felix in Italy, where he would be in the midst of his concert tour.

Lea Mendelssohn refused to make the trip; she saw no reason to leave her home. In the past, the only reason she traveled was for the education of her children and they were now grown. Even Fanny had some misgivings about spending the money the trip would cost. Although she came from a wealthy home, travel was done mainly for business or educational purposes and she worried her father, who controlled

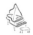

her money, would not approve of such an extravagance. She wrote to Felix,

> I live with a fear . . . that our parents might not be right to disapprove of our giving ourselves a treat as divine as it would be expensive, and which would absorb at the very least a whole year's income . . . I'm afraid our parents would hardly be pleased with such a plan and neither of us wishes to decide on anything without their consent.

Then, in December 1829, barely two months after their wedding, Fanny discovered that she was pregnant. All thoughts of a trip to Italy were put out of her mind.

The newlywed couple had moved into the garden house on the grounds of Number 3 Leipzigerstrasse that was cold in winter and hot in summer. As winter approached, the garden house became so cold and drafty that no amount of heating it could make it warm enough.

Hensel was very supportive of his wife's desire to compose music and urged her to continue to do so, even after she became pregnant. As Fanny wrote Felix soon after her marriage: "My husband has given me the duty of going to the piano every morning immediately after breakfast, because interruption upon interruption occurs later on. He came over this morning and silently laid the paper on the piano, and five minutes later I called him over and sang it to him exactly as it appeared here on the paper fifteen minutes later."

In March 1830, the now twenty-one-year-old Felix was about to depart for Italy to begin a concert tour through Europe that would last two years. Then Rebekka was stricken

with measles and soon Felix and Paul were sick and he had to postpone his departure.

When Felix recovered he left Berlin on May 13, accompanied by his father. His first stop was to be Munich, where he was scheduled to give some concerts. Fanny wrote in her diary, "Early this morning Felix left with Father, who will accompany him as far as Leipzig." Abraham returned to Berlin a few days later.

By the end of May, it was time for Fanny to stay at home to await the birth of her child. In the nineteenth century, pregnant women remained at home during the final months of their pregnancy. She was also advised by her doctor to remain in bed, because there was a chance that she would miscarry.

As she had when Felix was in England, she relied once again on her brother to be her window to the world. Her letters told him how much pleasure she got from hearing from him about the people he met, the concerts, and the new music he continued to compose. She also reported on her life at home. "My little arrangement here is very nice. The blue inkpot is on a small table next to my bed, a splendid sunny rose cutting is nearby, and the balcony doors are open and admitting glorious fresh air for the first time. I munch on strawberries every day, with which . . . my very prudent husband spoils me."

On June 16, 1830, Sebastian Ludwig Felix Hensel was born two months prematurely. He was named in honor of Fanny's favorite composers—Johann Sebastian Bach and Ludwig von Beethoven—and her brother, Felix. Because the infant was small and very weak, his survival was in question. She devoted all of her time to caring for her newborn infant.

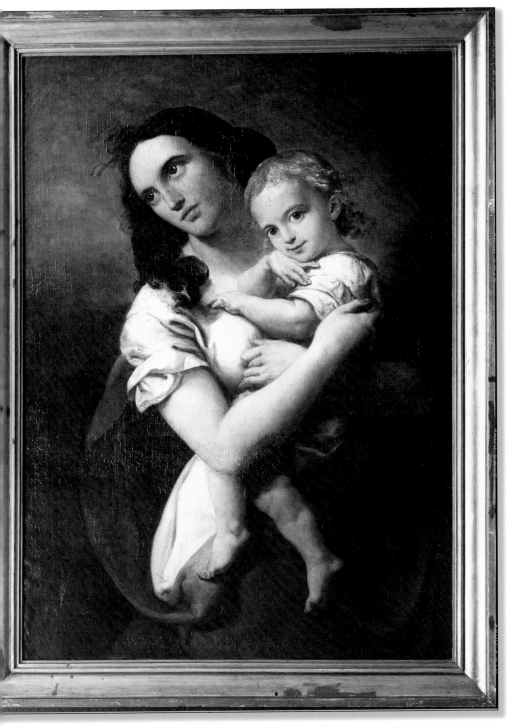

Fanny and her son, Sebastian Ludwig Felix Hensel (*Courtesy of Bildarchiv Preussischer Kulturbesitz/Art Resource*)

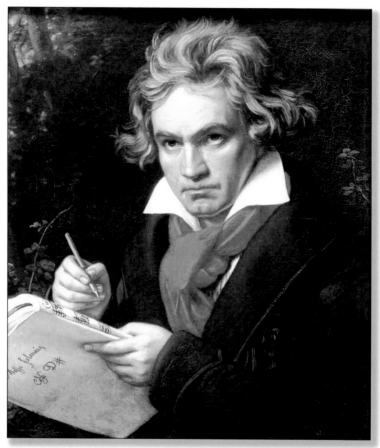

Fanny named her son after Ludwig von Beethoven, one of her favorite composers.

Three days after Sebastian's birth, she wrote to Felix, "My life is indescribably good."

Because of the excellent care, Sebastian gained weight quickly and was soon a normal weight for his age. By July, the doctor allowed her to take Sebastian to visit family and friends. She proudly told her brother, "Sebastian, whose progress you must follow in great detail, dressed for the first time today . . . he's grown into a regular child's outfit . . . from a little package that was bundled up and put into a tiny bed almost too pathetically."

Fanny was happy as a wife and mother. She wrote about her husband in her diary, "It seems impossible to us that our love and happiness can still increase, and yet that is the case: every day we fall more in love and every evening we tell each other how happy we are."

Each morning, Wilhelm Hensel went into the studio Abraham had built for him on the Mendelssohn property. He spent the entire day drawing and painting portraits of family members and many of the visitors to Number 3 Leipzigerstrasse, including artists, musicians, actors, singers, and writers. He also received commissions from wealthy people to paint their portraits and taught students who came to his studio for lessons. At four-thirty in the afternoon, Hensel took his main

Wilhem Hensel often spent the entire day drawing and painting pictures like this while Fanny played piano in the next room.

meal with Fanny before returning to his studio to draw and paint until the light was gone. In warmer weather and in the summertime, he painted outdoors in the garden.

Hensel's studio opened into the music room that held Fanny's piano. There he could watch his wife play the piano in the next room while he painted or taught his students and she could watch her husband work while she played the piano. It was a happy arrangement for both.

Felix described Fanny and Hensel in a letter to a friend. "Hensel is incredibly diligent and works all day long, in the strictest sense of the word. Fanny has acquired a comfortable, maternal side while retaining all her warmth and inner strength: I can never be too glad about her."

In the months after her son was born, Fanny devoted herself to caring for him. While she played the piano regularly, she did not compose any new music:

> I've gone back to being someone who devours new potatoes and takes walks in the evening air, someone capable of enjoying herself and who is enjoying herself, and everyday my little one grows bigger. I haven't done any composing yet; I had many ideas when I was not supposed to, but now the well-known drought is setting in, which I've picked up from the weather.

That summer, Fanny and Hensel planned to have their son baptized in the Lutheran church. She wanted Felix to be present, and when she realized that he could not return to Berlin in time she wrote him, "Who will baptize him? Wilmsen. Who will hold him? Beckchen. When? Around the middle of August. Who is to stand in for you? I've suggested Zelter; do

you object?" In the middle of August, Sebastian Hensel was baptized in the church where his parents had been married.

On the day Sebastian was baptized, Fanny wrote to her father, who was in Paris:

> I cannot allow such a joyful and beautiful day to come to an end, dear father, without writing to tell you how we have missed you. An event like this will make one's past life rise vividly before one, and my heart tells me I must again thank you . . . and I hope not for the last time, for guiding me to where I now stand, for my life, my education, my husband. . . . I truly know and feel how blessed I am, and this consciousness is, I think, the foundation-stone of happiness.

Her life was happy, but by the autumn of 1830 Fanny was worried she would never compose again. She expressed her fears to Felix, who was in Rome, but he was not supportive. He scolded her, "you cannot expect a man of my caliber to wish you musical ideas; you are insatiable to complain of their absence . . . if you really wanted to, you'd be able to compose . . . and if you don't want to, then why are you complaining so dreadfully? If I had my child to coddle, I wouldn't want to be writing scores . . . But seriously, the child is not yet six months old, and you'd already like to be thinking about something other than Sebastian? Be glad you have him."

While Fanny cared for her husband and young son, Rebekka was pursued by a number of suitors. One was a mathematics professor named Gustav Peter Lejeune Dirichlet. Rebekka had been introduced to him by Alexander Humboldt, a natural

scientist and friend of the Mendelssohns, when he brought Dirichlet with him to the Mendelssohns' garden, where Humboldt had set up an observatory to study his plants.

Gustav Dirichlet was born in 1805, the same year as Fanny. He was one of eleven children of a postal worker father, but received the best education his parents could afford because of his obvious intelligence. It was while studying in Paris that he met Humboldt, who later got him a job at the university in Berlin, where he did research in number theory and would become one of the most important mathematicians of his day.

In February 1831, Rebekka told her family that she wanted to marry Dirichlet. Just as when Fanny met Hensel, Lea Mendelssohn was not pleased with her second daughter's choice of a husband. However, she finally agreed to the marriage and Rebekka and Dirichlet were married in May 1832. Like Fanny and Hensel, the Dirichlets moved into an apartment at Number 3 Leipzigerstrasser after their marriage.

The summer of 1831 brought an outbreak of cholera to Berlin. Cholera is a bacterial infection of the stomach that begins with a bloated, crampy feeling and can progress through vomiting, kidney failure, seizures, and, if untreated, death. It originated in India and spread west into Europe, most likely through

LE CHOLÉRA

This cover of *Le Petit Journal* demonstrates the devastation and fear caused by the cholera epidemics that swept Europe in the nineteenth century.

food and water handled by infected people. At the time, there was no cure for cholera; a patient either recovered or died of the disease.

Fanny caught the contagious disease, but she recovered from it. Her only regret was that her illness kept her from spending as much time as she wanted to with Felix, who had returned home from his concert tour while she was sick. Almost fifteen hundred Berliners, including several Mendelssohn and Itzig family members, died during the epidemic.

The next year saw the deaths of two people who had been important in Fanny's life. Both Carl Friedrich Zelter, her childhood music teacher and the director of the Berlin Singakademie, and Johann Wolfgang von Goethe, the great German poet, passed away.

The death of Zelter left the directorship of the Singakademie open. All the Mendelssohns urged Felix to apply for the position. He agreed to do so, but was only twenty-three and was considered by the voting members of the Singakademie to be too young and inexperienced. Anti-Semitism also played a role. Although Felix had converted, he was still thought of as a Jew. He was offered a position as deputy director, a position he declined.

The Mendelssohns felt that Felix was clearly the heir to the directorship of the Singakademie because of his and his family's long association with Zelter and the music school. To show their dissatisfaction with the decision, all of the Mendelssohns, including Fanny, resigned their memberships and an association of many years came to an abrupt end.

seven
Music

With her resignation from the Singakademie, Fanny no longer had the prominent Berlin school as a musical outlet, leaving a void in her life. All that remained to her was to revive the Sunday musicales in her home. Lea Mendelssohn was older and no longer had the energy and Felix was no longer home on a regular basis to plan, rehearse, and conduct the musicales. When Fanny was well she took on the responsibility.

She discussed her plans with Felix, who replied enthusiastically, "I cannot tell you, my dear Fanny, how pleased I am by your plan for the new Sonntagsmusik (Sunday musicales). It's a brilliant idea and I implore you in God's name not to let it slip into oblivion; instead, you must ask your nomadic brother to compose something new for you. He'll be happy to do so, and is only too delighted with you and your idea."

Fanny decided to use both a chorus and an orchestra in her concerts when needed. The first thing she did was to put together a group of amateur singers for her chorus and locate professional musicians from the Konigstradt Theater in Berlin. Depending on the music played on a particular Sunday, she used one or both.

She also composed *Ouverture* for the orchestra to play at one of the Sunday musicales and conducted it herself. Afterwards, she told Felix, "Had I not been so shy, and embarrassed with every stroke, I would've been able to conduct reasonably well."

With a chorus and orchestra in place, there was still music to plan for each musicale. The creative drought Fanny had suffered from since Sebastian's birth disappeared. Between June 1831 and January 1832, she composed four cantatas for voices and orchestra to premier at her concerts.

The first, *Lobgesang (*Hymn*)*, was completed on June 14, 1831, in time for Sebastian's first birthday. It was written in a style similar to Johann Sebastian Bach, with singing parts for soprano and alto voices as well as chorus and orchestra.

On October 31, 1831, she completed a second cantata, which she called *Hiob* (Job*)*, based on the biblical story of Job and the terrible trials he went through to prove his faith in God. For this cantata, Mendelssohn used a full orchestra and a trio of vocal soloists—a soprano, a tenor, and a bass.

The third cantata, which she called *Oratorio*, was completed in late 1831. It also had a biblical theme but Fanny based the final cantata, completed in early 1832, on the tragic Greek legend of Hero and Leander. Hensel wrote the text and Fanny composed the music.

Felix also composed new music for his sister's musicales. *Die Erste Walpurgisnacht (*The First Sabbath Night*)*, was a cantata based on one of Goethe's poems about a fight between Christians and ancient Celtic priests called Druids. Before he completed it, Felix shared his ideas with Fanny, "I have partly composed Goethe's 'First Walpurgis-nacht,' but have not yet had courage to write it down. The composition has now assumed a form, it is become a grand cantata, with full orchestra, and may turn out well." Of all the pieces her brother composed, *Walpurgisnacht* would become Fanny's favorite. She included it very often in her Sunday concerts.

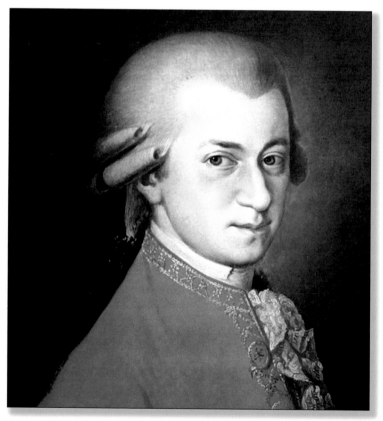

Fanny often used the Mendelssohn musicales to introduce the work of artists like Wolfgang Amadeus Mozart to the Berlin audience.

This watercolor of the Leipzig Gewandhaus was painted by Felix in 1836. Felix served as director of the Leipzig Gewandhaus Orchestra from 1835 to 1847.

Each Friday, she rehearsed the chorus and orchestra at Number 3 Leipzigerstrasse. On Sunday, she conducted them and played the piano as well.

The Sunday musicales became immensely popular among music-lovers of all classes of Berlin society. Through them Fanny introduced the music of Bach, Mozart, Beethoven, and Handel to Berlin, as well as premiered her own and Felix's works.

Early in 1833, after he had been denied the directorship of the Singakademie, Felix took a position in Dusseldorf to plan and direct its annual Lower Rhine Music Festival. When the festival was over, he stayed on in Dusseldorf to direct other musical activities for the next year. During that time, he was offered the position of director of the Leipzig Gewandhaus Orchestra and moved to Leipzig.

Fanny was busy as well. She had a large home to run, servants to direct, and a child and husband. There were also frequent guests, some of who stayed for several weeks or longer. It was up to the eldest daughter to see to their comfort and to entertain them.

Fanny also attended social gatherings at the homes of friends and family. By 1833, Abraham's eyesight had begun to fail and reading became a hardship. Fanny and her sister regularly read books and letters to their father. Fanny also continued to send Felix the new pieces she had composed and told him about the concerts. Her letters also brought him up-to-date about what went on at home. In October, she wrote, "I wish you could have been here last night. I had a spat with Beckchen which you would have loved—Mother and Father practically laughed themselves sick. It started over our husbands' waistlines and moved so far afield . . .

but then we couldn't keep it up because we were laughing so hard. We're very merry and well."

The Mendelssohns had rented out one of the apartments in their large house to tenants who were unrelated to them and Fanny wrote her brother about an unfortunate incident that occurred there in October 1833:

> We had a fire in the house recently. We've been spending our evenings quietly in our parents' house, above which General Braun has been living for a while with his several booted sons, rumbling about. But that evening the noise suddenly became deafening, with great running in every which way and very loud talking. Then a noise sounded as if it were raining in that room, accompanied by a veritable rain of chalk dust and crashing at our door. We all jumped up and discovered that the hall above us was burning. The men ran upstairs, and we couldn't because the old general was putting out a fire in the drapes with his shirt; he had ignited them earlier with a lamp.

She assured Felix that the fire had not spread further than the general's apartment and that only the smell of smoke remained.

For the next few years, Fanny seemed satisfied with her life as a wife, mother, composer, pianist, and conductor. But she still had little self-confidence in her musical abilities and knew the people who attended her Sunday musicales were not capable of offering musical analysis. Felix's judgment was still of paramount importance and in recent years he had become more critical. On one occasion, she told him, "I'm so unreasonably afraid of you anyway (and of no other person, except slightly of Father) that I actually never play [the

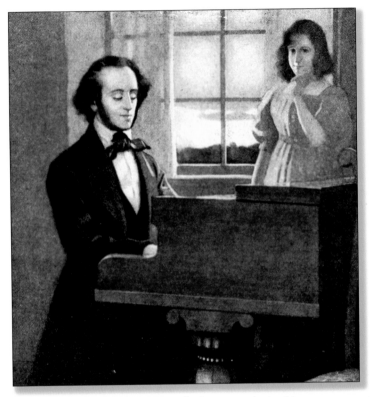

As Felix gained fame and respect, he became reluctant to encourage or compliment Fanny's compositions. *(Courtesy of Lebrecht Music and Arts)*

piano] particularly well in front of you, and I wouldn't even attempt to accompany [a singer] in front of you, although I know I'm very good at it."

But she began to hint at her disappointment in Felix's reluctance to compliment her musical compositions. She wanted him to know how important his approval still was to her. "It's necessary for you to know everything in my life and approve of it. Therefore I'm also very sad, truly not out of vanity, that I haven't been able to be grateful to you in such a long time for liking my music. Did I really do it better in the old days, or were you merely easier to satisfy?"

From time to time, her letters also alluded to her frustration at not being able to publish her music. She complained to Klingemann, "If nobody ever offers an opinion, or takes the slightest interest in one's productions, one loses in time not only all pleasure in them, but all power of judging their value."

Felix, on the other hand, performed in front of many people and many more could examine his published manuscripts. It began to seem unfair, even though she was proud of Felix and happy for his achievements.

Even so, she was still not able to fully express her desire to publish and only hinted at it to Felix. "In regard to my [plans to] publish . . . Hensel is for it, you are against it. In any other matter I'd naturally accede entirely to the wishes of my husband, but in this matter alone it's crucial to have your approval." But, Felix still opposed her desire to publish and she did not.

Abraham Mendelssohn died in 1835, at the age of fifty-nine. In honor of his father, Felix completed his oratorio, *St. Paul*, of which Abraham had been especially fond.

In May 1836, Fanny, along with Paul and his wife Albertine, traveled to Dusseldorf for the premier of *St. Paul*, which Felix conducted. Fanny joined the chorus for the premier performance, singing in the alto section. She knew the music so well that, when one of the soloists failed to appear on cue, Fanny hissed to alert him to come on stage and the performance continued flawlessly.

Fanny returned to Berlin, while Felix traveled throughout Europe giving concerts and composing new music. Fanny now seemed comfortable in her role as Felix's older sister. She even advised him that it was time for him to get married.

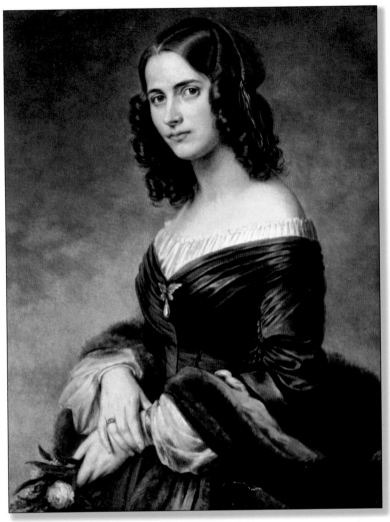

Cecile Mendelssohn, Felix's wife *(Courtesy of Lebrecht Music and Arts)*

Lea, too, urged him to marry. On a trip to Frankfurt, he met Cecile Jeanrenaud, an eighteen-year-old amateur singer in a local choral group whose members included the daughters of some of Frankfurt's most prominent families. Although the Jeanrenaud family was originally from Switzerland, they had lived in Frankfurt for many years. Cecile's father had been a pastor in Frankfurt before his death.

On March 28, 1837, Felix married Cecile Jeanrenaud. Fanny composed her piano Prelude in B flat minor for the occasion, although she did not meet her new sister-in-law until November, when she visited them in Leipzig.

Even before they met in person, Fanny had established a relationship with Cecile through letters. In October 1837, she wrote to her sister-in-law:

> What a pity it is that fate should have decreed that we are to live so far apart, and that he [Felix] should have had a wife these eight months whom I have never seen. I tell you candidly that by this time, when anybody comes to talk to me about your beauty and your eyes, it makes me quite cross. I have had enough of hearsay, and beautiful eyes were not made to be heard.

When they finally met, Fanny liked Cecile immediately. She wrote to Klingemann:

> At last I know my sister-in-law, and I feel as if a load were off my mind, for I cannot deny that I was very uncomfortable and out of sorts at never having seen her. She is amiable, childlike, fresh, bright and even-tempered, and I consider Felix most fortunate; for though inexpressibly fond of him, she does not spoil him. . . . Her presence produces the effect of a fresh breeze, so light and bright and natural is she.

In February of the following year, Fanny did something she had never done before. She performed Felix's Concerto in G minor in front of a public audience at a charity event. Prior to the concert, Felix applauded her, "You are indeed

playing in concert! *Bravississississisimo*. That is lovely and splendid; if only I could hear it!"

After the concert, Fanny told Klingemann, "I was not the least nervous, my friends being kind enough to undertake that part of the business for me, and the concert, wretched as the programme was, realized 2,500 thalers."

A review appeared a month after the concert in the influential Leipzig newspaper, *Allgemeine Muzikalische Zeitung*, which included a brief mention of her performance. "Then a sister of the composer performed the Concerto for Piano in g minor by F. Mendelssohn-Bartholdy rapidly and securely."

During the summer of 1838, Felix brought his family to Berlin for a visit. By that time, they had their first child, a boy named Carl Wolfgang Paul. Felix and Cecile would eventually have four children.

Then, in 1839, Fanny's life changed again, this time in a direction that would alter the rest of her life.

A Year in Italy

Fanny was, at last, going to take the trip she had dreamed about since 1822, when she had looked over the Alps into Italy. She and Wilhelm planned to leave Berlin with their son Sebastian in late August 1839 and travel south through Germany and Switzerland. Before they left she wrote in her diary, "God grant us a prosperous journey, without accident and with constant good news from home, and bring us back again to find no changes and then we shall have a glorious time. I look forward to this great event with quiet happiness."

They left Berlin on August 27, 1839. Their first stop was in Leipzig, where they spent a week with Felix and Cecile, who was pregnant with the couple's second child.

From Leipzig, they traveled to Munich. Fanny wrote in her letters home that the weather in Munich was mostly cool and rainy but she found Munich a more stimulating city than

Before spending a year in Italy, Fanny and Wilhem went to Leipzig to visit Felix and his wife. *(Library of Congress)*

Berlin and soaked up all the sights and met several new people. She wrote to Felix:

> We've been here two weeks and only scratched the surface. We could easily use twice as much time, because what is happening there in new art and the acquisition of art is very significant and meaningful on the highest level . . . You can imagine how much my husband has enjoyed seeing so many new ideas in his field as well as artists he's known in Rome. I knew no one here and therefore my head is stuffed full of new things and new people. It's always heartening to discover that people who are away from home are welcome and treated with great hospitality.

Wilhelm introduced her to his artist friends, and she met several musicians as well. She attended musical evenings

and was even asked to play the piano. Her high standards were always on display, as were her good manners. "At the request of the company I played as well as I could, but the instrument was rather out of tune," she reported back to her family in Berlin.

The Hensels left Munich on September 24 and continued southward into Switzerland. When they crossed the Alps into Italy, Fanny remembered her previous trip when she'd looked over the mountains and dreamed of going to Italy some day. "I must admit that my heart was gripped by inexpressible emotions," she said.

By October 13, they were in Venice, which Fanny found to be an enchanting city. She wrote to her family, "I do not remember in my whole life to have felt so much astonishment, admiration, emotion, and joy in any twenty-four hours as I have in this wonderful city of Venice . . . As one first approaches and sees it floating upon the water, one scarcely knows which to admire most, its grandeur or its fairy-like beauty."

They stopped at the Luna Hotel, which someone in Munich had recommended to them, but Fanny found the hotel to be infested with mosquitoes and they bit her mercilessly.

They were avid sightseers and walked all over the fabled city of canals. In a single morning, they went for a gondola ride on the canals and visited churches, museums, and art galleries to see the paintings of the great sixteenth-century Venetian artists such as Jacopo Tintoretto, Vecellio Tiziano (Titian), and Giovanni Bellini. What surprised her the most about Venice, however, were the large number of shops and cafés and the constant movement of people and traffic on the streets.

In the evening, they went to an outdoor band concert in a piazza crowded with people, including beautiful, elegantly-dressed women. At another piazza, where people from the lower classes were in attendance, they saw an outdoor fair. There was a marionette theater and a military band played its music. Two singers accompanied themselves on a violin and guitar and dozens of people fought and argued and children cried as vendors shouted their wares. The noise and commotion reminded Fanny of the streets of Paris.

When she returned to their hotel, Fanny discovered that the brooch she had worn was missing. Despite her protestations, Wilhelm hurried back to the piazza where they had seen the fair to look for his wife's brooch. Amazingly, he found it and returned the pin to his grateful wife.

A few days after their arrival in Venice, the Hensels moved out of their mosquito-infested hotel into an apartment. Fanny was much happier in the neat and clean apartment.

The weather turned cold by the end of October and Fanny and Wilhelm spent an hour each evening in a café drinking tea and reading the newspapers. They kept up with news from Germany. They read about the escalating unrest and demands for a constitution that would guarantee civil rights and freedoms.

A week later, on a rainy day, they packed their belongings and left for Padua, where they were forced to stop at the Po River by its swollen waters. The ferryman refused to take them across until the waters had receded.

They reached Rome on the night of November 26 and rented a sunny, four-room apartment on the third floor of a building there. Wilhelm was happy to be back in Rome, where

A panorama showing Rome as it would have looked during Fanny's year in Italy. *(Library of Congress)*

he was reacquainted with old friends. Fanny was determined to be pleasant and polite to her new friends. "The names of Wilhelm and Felix are like two sweet pillows for me here. I am thus at greater pains and must be devilishly nice to be a credit to my family."

At first, foul weather kept them from taking full advantage of being in Rome. During that time, Fanny played the piano in a concert at the home of Ludwig Landsberg, a violinist who had been in the orchestra of the Konigstadt Theater in Berlin. She thought that the quality of the concert was not on a par with her Sunday musicales. Landsberg, who rented out pianos to people for a living, offered to rent her one at a discount, but she declined because his pianos did not meet her standards of quality.

Like the other women of her time, Fanny had to sit in the back of the Sistine Chapel during the Papal ceremonies.

When the weather turned sunny they were finally able to see the sights of Rome and its surrounding countryside. Fanny noticed that Rome seemed to be filled with unmarried men and there were few women and children. "Children are among the rarities here; ancient monuments are far more numerous," she wrote. She did, however, find an eight-year-old boy to be a companion for nine-year-old Sebastian. She hoped Sebastian would learn some French and Italian from the child.

Fanny wrote Felix and brought him up-to-date on her life in Rome:

> We're enjoying a pleasant life here. We have a comfortable, sunny apartment and thus far have enjoyed the nicest weather almost continuously. And since we're in no particular hurry, we've been viewing the attractions of Rome at our leisure, little by little. It's only in the realm of music, however, that I haven't experienced anything edifying since I've been in Italy.

Fanny visited the Sistine Chapel to listen to the Papal music there. Because she was a woman, she had to sit in the back of the chapel, behind a grill that separated the women's section from the men's. The distance and the dim light from the smoky candles made it difficult to see what was going on and distorted the music, which she found to be poor in comparison to the music played at the Berlin Singakademie.

Fanny returned to the Sistine Chapel later, and, this time, had a more favorable impression. "I found a place right in front and since the Swiss guard later allowed a few women to draw near the grill, this time I had a remarkably good view of all the ceremonies," she reported to Felix.

As Christmas 1839 approached, Fanny prepared a Christmas tree for Sebastian in their rented apartment with branches from cypress, myrtle, and orange trees. Their cook, who had traveled with them from Berlin, baked German cakes. Even though it was the first time she had ever been away from home during this holiday season, and she and Sebastian were homesick, it was a happy time. They exchanged Christmas presents. Wilhelm gave his wife a small cabinet with ivory

inlays on it and she gave him a sketch drawn by the sixteenth century painter, Paolo Veronese.

They visited Casa Bartholdy, the house Fanny's uncle Jacob Bartholdy had lived in before his death. People from England now owned the house and they allowed them to wander through the house and around the grounds.

In February, Wilhelm became ill and until he was well they remained in the apartment. Fanny spent the next six weeks nursing him back to health. He regained his strength by carnival time and they resumed their visiting and sight-seeing. The streets of Rome were filled with revelers tossing confetti and other small items at each other as the Hensels drove along the Corso, a boulevard. Fanny had more fun watching the merriment than she had expected and wrote to her mother, "Do you recognize me, dear Mother, having fun for hours amid a hum and noise that cannot be compared either to the roar of the sea, or to the roaring of wild beasts, but only to the Corso in Rome?"

Fanny also enjoyed the mild winter in Rome, which was so

Fanny enjoyed a carnival while in Rome.
(*Courtesy of Bridgeman Art Resources*)

different from the bitterly cold winters of Berlin. She wrote Felix:

> I believe that once a person has tasted such a winter, he will always have regrets. I truly would not want to be an Italian, or anything else but a German, but it wouldn't be so bad if we could move our dear fatherland a little farther south. Mother wrote me yesterday that it was 12 degrees in Berlin on the 19th, and we're still living here without coats and practically without a fire. That's one of life's material comforts that ranks at the top of the list.

By spring, they had made a small circle of artistic friends that included three students from the Villa Medici, home of the French Academy. Georges Bosquet and Charles Gounod, were musicians, and Charles Dugasseau a painter. They also befriended a trio of German painters, August Kaselowsky, Eduard Magnus, and Friedrich August Elsasser, and Charlotte Thygeson, an amateur pianist.

They settled into a routine. In the morning, Wilhelm sketched and painted, then he and Fanny had

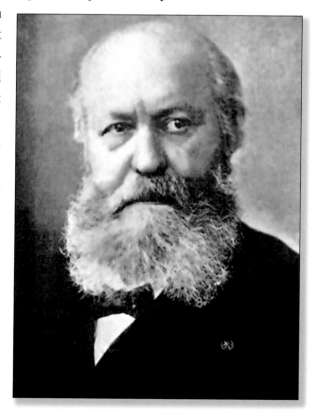

Charles Gounod,
French composer

lunch and went for a walk. In the evening, they either went out or invited friends in and played music. "We haven't spent three evenings alone this winter, it seems to me," Fanny wrote Rebekka. She frequently played her own compositions as well as Felix's and the music of Bach for their friends in the evening.

As they were accustomed to do in Berlin, Fanny often played the piano while her husband painted. In her diary, she wrote, "The Frenchmen came in the evening, and Wilhelm began doing their portraits. Naturally there were a lot of jokes while this was going on. Whoever was posing had the right to choose what I should play."

The French musicians admired Fanny's musical abilities. "They never forget what I've played for them several months before, even if it was only once; one really could not have a better audience," she wrote. "I'm also doing a lot of composing at the moment; nothing stimulates me more than being appreciated, just as disapproval disheartens and depresses me." Their praise gave her a self-confidence she had not experienced before.

Charles Gounod was especially impressed by her musical talent. She introduced him to the music of the German composers Bach, Beethoven, and Felix Mendelssohn. She also played some of her own compositions. Gounod wrote about her, "Madame Hensel was a musician beyond comparison, a remarkable pianist, and a woman of superior mind; small and thin in person but with an energy that showed itself in her deep eyes and in her fiery glance. She was gifted with a rare ability as a composer."

Fanny in turn liked Gounod's enthusiasm and was flattered by the attention he paid her. "I have known few people who

can enjoy themselves so wholeheartedly or so thoroughly as he," she wrote.

In May, Fanny and Wilhelm and their friends went on a unique picnic. Each was asked to create something original in their field. The artists were asked to paint a picture; the musicians to compose a piece of music. Fanny and Georges Bosquet exchanged poems and each set the other's work to music.

After lunch, all the picnickers gathered to share their newly-created art and music. That evening, they gave a concert of the music they had rehearsed.

Fanny and Wilhelm had originally planned to leave Rome at the end of May but they enjoyed the city so that when the time came they were reluctant to leave. Fanny reveled in the attention, and life in Rome was more casual than in Berlin. Fanny, who came from a rigid tradition, enjoyed the freedom and informality of life in Rome while Wilhelm had renewed old acquaintances and sketched and painted prolifically. But in spite of their love for this city, they both knew that it was time to leave. Fanny summed up her feelings:

> It's costing both of us a great sacrifice to leave Rome; I would never have thought that it could make so deep an impression on me. I won't deny that finding myself surrounded by such admiration and respect is partly responsible. I was never courted like this when I was young, and who can deny that it's very pleasant and encouraging? Everything here is conspiring to keep me in Rome—and how wonderful that would be for my Wilhelm and his work! But it isn't possible, and our decision is firm.

They left for Naples on May 31, 1840, and then planned to visit Genoa and Milan. In Naples, they stayed in a house with a balcony that overlooked the bay and visited the museums and churches and the ruins of Pompeii. For Sebastian's tenth birthday they took him to see the volcano at Mount Vesuvius. Gounod and Bosquet visited and they went for a boat ride. Fanny also swam in the Mediterranean Sea, another new experience.

By now they were tired and were anxious to get home to Berlin, although they still planned to see Genoa and Milan first. Finally, in late August, they crossed the Alps back into Switzerland and on August 28, they crossed the border into Germany. They arrived in Berlin on September 11.

They had been gone more than a year. It had been the happiest year of Fanny's life. It was also a year that changed her self-perception. The insecure person who had left Berlin was replaced by a self-confident woman, secure in the knowledge that she was a talented pianist and composer.

The Final Years

Although the year she had spent in Italy was exhilarating, Fanny was glad to be home. She was homesick for Number 3 Leipzigerstrasse and for the family she had left behind in Germany. She especially missed Felix. She had seen very little of him during the past years. He lived in Leipzig and traveled extensively giving concerts. Her childhood and adolescence had been so intertwined with Felix's that it was still difficult to only see him occasionally. Although Leipzig was just a day's journey from Berlin, she wished they lived closer to one another.

Soon after returning to Berlin, Fanny wrote and told Felix how separated she felt from him. "It's truly a terrible mistake in our lives that for the past ten years we haven't spent time together with the exception of a few days at best, which seem stolen in haste. This will very likely continue for the rest of our lives as well. It wouldn't hurt us to be together."

Fanny quickly became involved once again in activities with friends and family. Her letters to Felix were filled with anecdotes of what people did, especially the children. Sebastian got along with Rebekka's son, Walter, who was three years younger. "They couldn't be closer if they were brothers. They're inseparable and haven't squabbled even once. Next week, they'll start school together—of course not in the same class—but they look forward to it very much. It's really a joy to see them go into the garden arm in arm."

Fanny had been educated at home by tutors, but she and Wilhelm wanted their son to go to school. They sent Sebastian to a school just down the street from their home.

Meanwhile, Fanny spent the fall and winter composing music. She wrote a series of twelve pieces for the piano she called *Das Jahr* (The Year), to celebrate her year in Italy. There was a separate piece for each month. *February* was

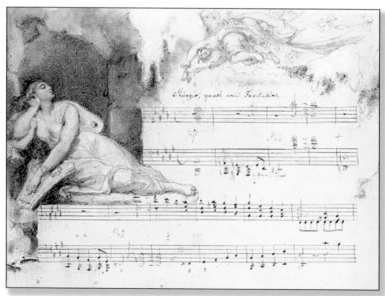

"Score of January," the first piece in Fanny's *Das Jahr*, illustrated by Wilhelm Hensel.

in honor of the Roman carnival, for example. The pieces she wrote to represent June and July reflected the pleasure of being in Rome and Naples. Near the end of 1840, she wrote the last piece, *December*. She added a thirteenth piece, called Nachspiel (Postlude), about the journey home. Besides *Das Jahr*, she composed other music, including *Einleitung zu lebenden Bildern* (Introduction to Tableaux Vivants).

Although she was busy as a composer, wife, and mother, Fanny continued to miss Felix, and her brother Paul, who traveled considerably in his position as a banker. She lamented to Felix:

> It's really a sad tale to think that we haven't been together once since we've been back. When will we be able to be together sometime—that means with you too? I might even say that I long to see you once when there's more time available than merely saying hello and goodbye, and for the past three years it hasn't been otherwise.

On a December morning in 1840, Fanny braved the bitter cold to run an errand for Felix. She went to the Singakademie to get copies of some of the Bach scores Zelter had donated to the school. Felix wanted the manuscripts to play the music in his concerts. She was glad to do a favor for her brother and kept him informed as she went about acquiring the copies.

By the end of 1840, Fanny had resumed the Sunday musicales, which sometimes included new music by Felix. One of the works he sent her was *Psalm 114, Da Israel aus Agypten zog* (When Israel Came Out of Egypt*)*, written for two choruses and orchestra in 1839. Fanny reported on its

performance in a letter, "As you already know from Mother, I had your *Psalm* performed on Sunday, and it went surprisingly well after only 2 rehearsals. The choir consisted of 25 members, an imposing group . . . the piece really sounded powerful. We placed it at the beginning [of the concert] and had to repeat it at the end."

The winter of 1840–1841 was bitterly cold and snowy in Berlin. Fanny, Rebekka, and Wilhelm were all sick at some point and had to remain in bed. By March 1841, the long winter had taken its toll on her nerves. "This winter has been very long and severe, and I assure you that the piles of snow ever present in the garden over the last four months wear on my soul much more than my eyes. Every night frozen windows still, during the day slight melting in the sun," she wrote.

In March, Fanny agreed to play in a concert with other nonprofessional women musicians. She discussed her musical selection with Felix. "I'll play your Trio," she told him, referring to his Trio in D minor, then went on to say:

> Actually, I should have selected the Serenade for the concert hall, but it doesn't lie well in my fingers and I haven't been able to learn it yet. The Trio, however, although perhaps no less difficult, lies more comfortably, and since I'm not accustomed to playing in public, I must choose something that won't worry me.

Between 1840 and 1841, the number of nieces and nephews increased. Rebekka gave birth to another son, whom she named Ernst, and Felix and Cecile had a third child, Paul.

During the winter of 1841–1842, Fanny was ill again. She wrote to Felix on December 5 about the "numerous wars waged by everyone in the house over the past few weeks against coughs, sore throats, nosebleeds . . . enemies of the worst kind . . . But this time my nosebleed wasn't as bad as last year; a very solid cold is helping out now."

A week later, Lea Mendelssohn fainted while at home entertaining friends and family. She died peacefully the next morning, December 12. Fanny wrote in her diary:

> A more happy end could not have been desired for her. She was taken literally as she told Albertine last summer she should like to be, knowing nothing about it and without being laid up, but engaged to the last in the ordinary course of her pleasant daily life, and in the full enjoyment of her intellectual facilities.

The Mendelssohn family did not celebrate Christmas that year to mourn for their mother.

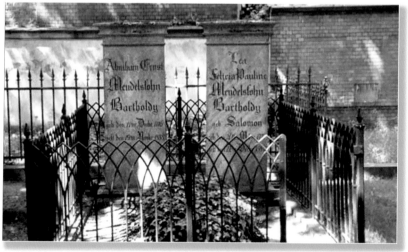

A picture of Abraham and Lea Mendelssohn's graves *(Courtesy of David Conway)*

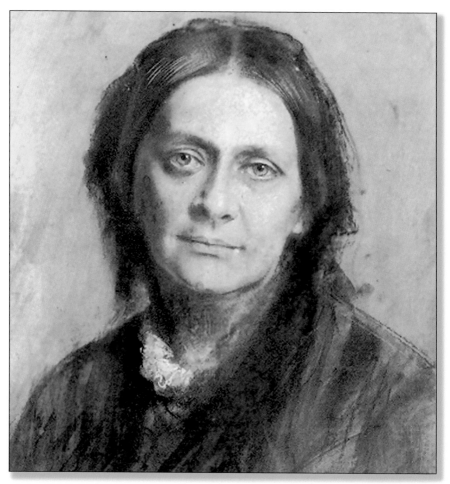

Clara Schumann

The Hensel family traveled to Leipzig to visit Felix and Cecile and their family in February 1843. Instead of going by coach, they used a form of public transportation that was little more than a year old—the train. It took hours to go from Berlin to Leipzig, where previously it had taken a full day to travel by coach.

A great deal of music was played during the week they spent together in Leipzig. Clara Schumann, a pianist and composer, was one of the musicians in attendance. Schumann was among the foremost pianists of the time and Fanny was

enormously impressed by her musical ability. "She plays ravishingly well," she wrote.

Charles Gounod stopped in Berlin at the end of April on his way home to France. For two weeks, he was a guest at Number 3 Leipzigerstrasse. Fanny described the visit, "He stayed here for the entire time without going out, and was given a very friendly welcome by the whole family. He saw nothing of Berlin, except for our house and garden, and the family, and heard nothing except what I played for him, although we encouraged him to look around."

Gounod's visit reaffirmed her belief in her musical talents. "His presence was a very lively musical stimulus for me, for I played and discussed music a great deal with him during the numerous afternoons I spent alone in his company," she wrote.

That summer, Rebekka and her family left Berlin for Italy. Months earlier, Rebekka's youngest child had died at the age of thirteen months and it was hoped the trip would help Rebekka get over the child's death. At the same time, Wilhelm Hensel went to England to get work as a painter.

Fanny stayed at home in Berlin. She composed many pieces of music that fall, including a piano sonata in G minor written in the Romantic style. She also wrote a piece inspired by the play, *Faust*, about a man who sells his soul to the devil.

Fanny also traveled to Potsdam to see Felix conduct *A Midsummer Night's Dream* at the Royal Theater. She attended the dress rehearsal on the day prior to the first performance and, with Sebastian at her side, watched the premiere. Other members of the Mendelssohn family were present as well.

When Felix was in Berlin he participated in Fanny's musicales. The siblings performed both together and separately.

After a performance on December 3, Fanny wrote, "Yesterday, the final *Sonntagsmusik* of the year, which was very popular. I played Beethoven's Trio in E-flat and Felix and I played Beethoven's Polonaise, and the Entr'actes (Intermissions) from *A Midsummer Night's Dream*, much to everyone's delight."

Felix's *The First Walpurgisnacht* was also played at a musicale. It was one of Fanny's favorite works and received a tremendously positive response from the audiences that heard it.

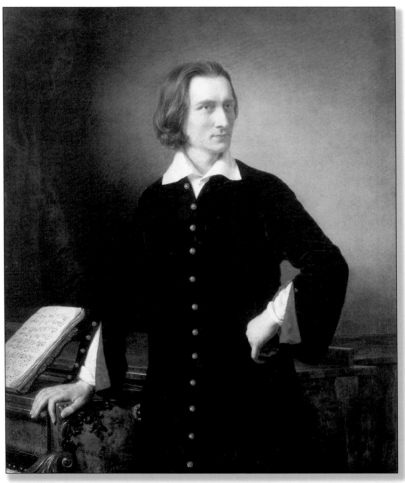

Famous Hungarian composer Franz Liszt was among the many members of royalty and upper class who attended Fanny's musicales.

The Sunday musicales continued on and off in 1844. Because of the quality of the music and performances they were very popular. Royalty and members of the upper class sought invitations. In March, Fanny wrote Rebekka, "Last Sunday we had what was, I think, the most brilliant musicale ever to see daylight, in regard both to the audience and the performance . . . there were twenty two carriages with their horses in the courtyard, and that [composer Franz] Liszt and eight princesses were present in the room." The last concert of the season was in June.

While the Dirichlets were in Naples, Italy, Rebekka became ill. Fanny and Wilhelm hurried to nurse her sister. Rebekka was also pregnant and gave birth prematurely to a daughter, named Florentina. The baby was christened on March 12, 1845.

While Fanny attended to her sister, Hensel went to Rome to find materials for his paintings. After Florentina's christening, Fanny joined him in Rome, where she visited with Charlotte Thygeson.

In mid-June, the Hensels and the Dirichlets set off together for Berlin and arrived home in early August. There was political unrest in Germany in 1845 that would eventually lead to revolution in 1848. Members of the lower classes clamored for their rights of full citizenship, which had long been denied them by the government. It was during this political turmoil and social upheaval that Fanny began to publish her work.

Wilhelm had long thought that she should publish and a new acquaintance, Robert von Keudell, himself a musician, also urged her to publish. She wrote, "Keudell keeps my music alive and in constant activity, as Gounod did once. He takes an intense interest in everything that I write, and

calls my attention to any shortcomings; being generally in the right too."

At the same time, two Berlin music publishing companies sought Fanny out. Both made her an offer she could not refuse and she selected a few pieces of what she considered to be her best work and allowed one of the companies, Bote & Bock, to publish them.

She wrote to Felix about her decision, although she knew he did not think she should publish. "I have Herr Bock's sincere offer for my songs and have finally turned a receptive ear to his favorable terms." When her brother did not respond quickly to her letter her feelings were hurt. But, Felix was ready to welcome his sister into the ranks of professional composers. "May you have much happiness in giving pleasure to others; may you taste only the sweets and none of the bitterness of authorship; may the public pelt you with roses and never draw black lines upon your soul—all of which I devoutly believe will be the case," he wrote.

Fanny confided to her diary, "At last Felix has written, and given me his professional blessing in the kindest manner. I know that he is not quite satisfied in his heart of hearts, but I am glad he has said a kind word to me about it."

Only about a dozen pieces of Fanny Mendelssohn's music were published during her lifetime. The first group, *Sechs Lieder* (Six Songs), came out in 1846. Among them were *Schwanenlied* (Swan Song), *Warum sind denn die Rosen so blass* (Why then are the roses so pale?) and *Maienlied* (May Song), all set to poems written by German poets.

Vier Lieder für das Pianoforte (Four Songs for the Piano) and *Gartenlieder* (Garden Songs) were also published that year. They were immediately successful, which encouraged her to

attempt larger works. She composed a *Piano Trio in D Minor* for piano, violin, and cello. When it was published after her death it became widely considered to be her masterpiece.

In 1847, Fanny published more of her songs and piano pieces. The publications allowed her music to reach a larger audience and encouraged her to compose in larger forms.

On May 14, 1847, Fanny held a rehearsal for her upcoming Sunday concert. A chorus sang and she accompanied them on the piano, but her hands suddenly felt numb. She soon lapsed into unconsciousness. A doctor was called, but to no avail. That night, Fanny Mendelssohn Hensel died. In his book, Sebastian Hensel recorded that what killed his mother was a sudden rush of blood to her head. She probably died of a stroke.

Obituaries in the newspapers referred to Fanny as a gifted composer, pianist, and rare talent, and the depth of feeling her recently published music contained.

The shocked Mendelssohn family were thrown into deep mourning. Felix told Wilhelm Hensel, "we have nothing left now but to weep from our inmost hearts; we have been so happy together, but a saddened life is beginning now." Felix died six months later and was buried beside her in the cemetery of the Dreifaltigkeitskirche (Trinity Church).

Hensel outlived his wife by fifteen years, but never fully recovered from the loss. Fanny had taken care of their home, their son, their finances, and their social engagements, leaving him free to pursue his career. With her death, his life was forever changed.

Fanny Mendelssohn Hensel was unfortunate enough to have lived in a time when women of her class could not have careers. In addition, she always tried to please her father and

her brother, often putting their interest above hers. But despite these obstacles, Fanny Mendelssohn had a passionate desire to compose music. She wrote an estimated four hundred pieces of music, including songs, piano pieces, choral pieces, and works for piano and orchestra. Only a small portion of her music has been published, including pieces published after her death. The rest remain in private hands, mostly those of Mendelssohn family members, and in the archives of the Prussian State Library in Berlin, Germany.

There is a renewed interest in Fanny's work. Many of her compositions are being published and performed for the first time. Finally, audiences can hear the music of Felix Mendelssohn's gifted sister.

Timeline

1805 Born in Hamburg, Germany on November 14; eldest child of Abraham and Lea Mendelssohn.

1809 Brother, Felix, born on February 3.

1810 Takes first piano lessons from mother.

1811 Sister, Rebekka, born on April 11; family moves to Berlin, Germany.

1813 Brother, Paul, born on October 30.

1816 Goes to Paris with family; studies piano with Marie Bigot.

1818 Returns to Berlin; studies musical theory and composition with Ludwig Berger and Carl Friedrich Zelter; plays Preludes from Bach's *The Well-Tempered Clavier* from memory for father's birthday.

1819 Composes first song, "Songs, Fly Joyously Away!," for father's birthday.

1820 Joins prestigious Berlin Singakamedie with brother Felix; composes thirty-eight songs and eleven piano pieces.

1821 Meets Wilhelm Hensel, an artist, at exhibition in his studio; father forbids her to be a professional composer because of her gender.

1822 Family travels to Switzerland.

1824 Composes her thirty-second fugue; Sunday concerts begin in Mendelssohn home.

1825 Family moves to Number 3 Leipzig Street, Berlin.

1827 Publishes three songs under brother Felix's name.

1829 Marries Wilhelm Hensel on October 3.

1830 Gives birth to son, Sebastian, on June 30; publishes three more songs under Felix's name.

1831 Composes four cantatas for voice and orchestra.

1835 Father dies.

1837 Publishes first song under own name.

1838 Plays piano in only public appearance at benefit concert.

1839 Leaves for Italy with family; spends one year there.

1840 Composes *The Year* to commemorate her visit to Italy.

1842 Mother dies; continues to compose; plays piano, conducts orchestra and chorus at Sunday concerts at home.

1846 Six songs published by Bote & Bock, a German publishing company.

1847 Dies suddenly of stroke while preparing for a concert at home.

Sources

CHAPTER ONE: A Childhood of Privilege

p. 11, "Bach-fugue fingers," Sebastian Hensel, *The Mendelssohn Family (1729-1847) from Letters and Journals, vol. 1.* (New York: Greenwood Press, Publishers, 1968), 73.

p. 14, "I married my husband . . ." Herbert Kupferberg, *The Mendelssohns: ThreeGenerations of Genius.* (New York: Charles Scribners' Sons, 1972), 94.

p. 18, "You know Baillot's sensitive . . ." R. Larry Todd, ed., *Mendelssohn: A Life in Music.* (New York: Oxford University Press, 2003), 35.

p. 20, "Of your two letters . . ." Hensel, *The Mendelssohns Family*, 77.

p. 20, "I cannot deny myself . . ." Ibid., 77-78.

p. 21, "My musical concoction is . . ." John Michael Cooper and Julie D. Prandi, ed., *The Mendelssohns: Their Music in History.* (New York: Oxford University Press, 2002), 234.

p. 22, "We raised you and . . ." Francoise Tillard, *Fanny Mendelssohn.* (Portland, Oregon: Amadeus Press, 1992), 48.

CHAPTER TWO: Discouragement

p. 29, "You must not be . . ." Janet Nichols, *Women Music Makers: An Introduction to Women Composers.* (New York: Walker and Company, 1992), 20.

p. 29, "I have decided to . . ." Tillard, *Fanny Mendelssohn*, 80.

p. 29, "What you wrote to . . ." Hensel, *The Mendelssohn Family*, 82.

p. 30, "The idea of a . . ." Kupferberg, *The Mendelssohns: Three Generations of Genius*, 98.

p. 32, "I miss you from . . ." Gail Smith, "Tribute to Fanny Mendelssohn Hensel" *Creative Keyboard* (http://www.creativekeyboard.com/feb05/tribute.html), 2.

p. 32, "This unwelcome guest has . . ." Tillard, *Fanny Mendelssohn*, 97.

p. 32, "This week I still . . ." Marcia J. Citron, *The Letters of Fanny Hensel to Felix Mendelssohn.* (Stuyvesant, New York: Pendragon Press, 1987), 7.

p. 32, "First of all, dear . . ." Tillard, *Fanny Mendelssohn*, 97.

p. 33, "Early yesterday I showed . . ." Rudolf Elvers, ed. and Craig Tomlinson, trans., *Felix Mendelssohn: A Life in Letters.* (New York: Fromm International Publishing Corporation, 1986), 9.

CHAPTER THREE: Journey to Switzerland

p. 37, "We laugh incessantly and . . ." Tillard, *Fanny Mendelssohn*, 112.

p. 37-38, "How grateful you must . . ." Ibid., 113.

p. 39, "My failure was such . . ." Hensel, *The Mendelssohn Family*, 108.

p. 39, "very broad and fertile" Ibid., 109.

p. 39, "I have spent a . . ." Ibid.

p. 41, "The cutting wind, which . . ." Ibid., 110.

p. 42, "I have watched his . . ." Nichols, *Women Music Makers*, 23.

p. 44, "My older siblings stole . . ." R. Larry Todd, ed., *Mendelssohn and His World*. (Princeton, New Jersey: Princeton University Press, 1991), 87.

p. 44-45, "I did not want . . ." Tillard, *Fanny Mendelssohn*, 87.

CHAPTER FOUR: Separation

p. 50, "This Felix Mendelssohn is . . ." Tillard, *Fanny Mendelssohn*, 118.

p. 51, "A whole row of . . ." Ibid., 124-125.

p. 52, "This boy will do . . ." Kupferberg, *The Mendelssohns: Three Generations of Genius*, 118-119.

p. 52, "You go to Paris . . ." Tillard, *Fanny Mendelssohn*, 121.

p. 53, "On Sunday afternoon we . . ." Citron, *Letters of Fanny Hensel to Felix Mendelssohn*, 12-13.

p. 54, "clarity and truth, richness and . . ." Ibid., 15

p. 55, "To me alone he . . ." Kupferberg, 120.

p. 56, "Altogether he has devoted . . ." Hensel, *The Mendelssohn Family*, 151.

p. 56, "The Christmas-candles are . . ." Ibid., 150-151.

p. 57, "Gentlemen may laugh at . . ." Ibid., 151.

p. 58, "You must become more . . ." Kupferberg, 156.

CHAPTER FIVE: Marriage

p. 59, "This year will bring . . ." Tillard, *Fanny Mendelssohn*, 184.

p. 60, "As soon as the . . ." Hensel, *The Mendelssohn Family*, 172.

p. 61, "A beautiful keepsake we . . ." Ibid.

p. 61, "But you should hear . . ." Kupferberg, *The Mendelssohns: Three Generations of Genius*, 1 56.

p. 61, "I never doubted your . . ." Citron, *Letters of Fanny Hensel to Felix Mendelssohn*, 45.

p. 62, "You will not misunderstand . . ." Hensel, 185.

p. 62, "Once again I need . . ." Citron, 57.

p. 62, "Please give them a . . ." Ibid., 48.

p. 64, "We are very busy . . ." Hensel, 241.

p. 64, "Again you have brilliantly . . ." Ibid., 240.

p. 64, "The beautiful veil has . . ." Ibid.

p. 65, "This then is the . . ." Ibid., 229-230.

p. 68-69, "Therese, crowned with roses . . ." Tillard, 180.

p. 69, "They wore quite different . . ." Ibid.

CHAPTER SIX: Motherhood

p. 71, "I live with a . . ." Tillard, *Fanny Mendelssohn*, 186.

p. 71, "My husband has given . . ." Citron, *Letters of Fanny Hensel to Felix Mendelssohn*, 96.

p. 72, "Early this morning, Felix . . ." Ibid., 99.

p. 72, "My little arrangement here . . ." Ibid, 101-102.

p. 74, "My life is indescribably . . ." Citron, *Letters of Fanny Hensel to Felix Mendelssohn*, 102.

p. 74, "Sebastian, whose progress you . . ." Citron, *Letters of Fanny Hensel to Felix Mendelssohn* ,103.

p. 75, "It seems impossible to . . ." Tillard, *Fanny Mendelssohn*, 189.

p. 76, "Hensel is incredibly diligent . . ." Tillard, *Fanny Mendelssohn*, 190.

p. 76, "I've gone back to . . ." Ibid., 192.

p. 76-77, "Who will baptize him . . ." Citron, *Letters of Fanny Hensel to Felix Mendelssohn*, 107.

p. 77, "I cannot allow such . . ." Hensel, *The Mendelssohn Family*, 252-253.

p. 77, "you cannot expect a . . ." Tillard, *Fanny Mendelssohn*, 193.

CHAPTER SEVEN: Music

p. 80, "I cannot tell you . . ." Tillard, *Fanny Mendelssohn,* 202.

p. 81, "Had I not been . . ." *Mendelssohn, Schumann/ Falletta, The Women's Philharmonic.* CD-ROM. Koch International Classics, 1992.

p. 82, "I have partly composed . . ." Hensel, *The Mendelssohn Family,* 277.

p. 84, "I wish you could . . ." Citron, *Letters of Fanny Hensel to Felix Mendelssohn,* 111.

p. 85, "We had a fire . . ." Ibid., 112-113.

p. 85-86, "I'm so unreasonably afraid . . ." R. Larry Todd, ed., *Mendelssohn and His World.* (Princeton, New Jersey: Princeton University Press, 1991), 95.

p. 86, "It's necessary for you . . ." Ibid.

p. 87, "If nobody ever offers . . ." Carol Neuls-Bates, ed., *Women in Music: An Anthology of Source Readings from the Middle Ages to the Present.* (New York, Harper & Row, Publishers, 1982), 147-148.

p. 87, "In regard to my . . ." Nichols, *Women Music Makers,* 27.

p. 87, "what a pity it . . ." Kupferberg, *The Mendelssohns: Three Generations of Genius,* 190-191.

p. 87, "At last I know . . ." Ibid., 191.

p. 87-88, "You are indeed playing . . ." Citron, *Letters of Fanny Hensel to Felix Mendelssohn,* 259.

p. 90, "I was not the . . ." Hensel, *The Mendelssohn Family,* 37.

p. 90, "Then a sister of . . ." Citron, *Letters of Fanny Hensel to Felix Mendelssohn,* 259.

CHAPTER EIGHT: A Year in Italy

p. 91, "God grant us a . . ." Hensel, *The Mendelssohn Family,* 57.

p. 92, "We've been here two . . ." Citron, *Letters of Fanny Hensel to Felix Mendelssohn,* 280.

p. 93, "At the request of . . ." Hensel, *The Mendelssohn Family,* 66.

p. 93, "I must admit that . . ." Tillard, *Fanny Mendelssohn,* 267.

p. 93, "I do not remember . . ." Hensel, *The Mendelssohn Family,* 67.

p. 95, "The names of Wilhelm . . ." Tillard, *Fanny Mendelssohn,* 270.

p. 96, "Children are among the . . ." Ibid., 271.

p. 97, "We're enjoying a pleasant . . ." Citron, *Letters of Fanny Hensel to Felix Mendelssohn,* 282.

p. 97, "I found a place . . ." Tillard, *Fanny Mendelssohn,* 276.

p. 98, "Do you recognize me . . ." Ibid., 274.

p. 99, "I believe that once . . ." Citron, *Letters of Fanny Hensel to Felix Mendelssohn,* 284.

p. 100, "We haven't spent three . . ." Tillard, *Fanny Mendelssohn,* 280.

p. 100, "The Frenchmen came in . . ." Ibid., 281.

p. 100, "They never forget what . . ." Ibid., 280.

p. 100, "Madame Hensel was a . . ." Todd, *Mendelssohn and His World,* 96.

p. 100-101, "I have known few . . ." James Harding, *Gounod.* (New York: Stein & Day, Publishers, 1973), 43.

p. 101, "It's costing both of . . ." Tillard, *Fanny Mendelssohn,* 280.

CHAPTER NINE: The Final Years

p. 103, "It's truly a terrible . . ." Citron, *Letters of Fanny Hensel to Felix Mendelssohn,* 294.

p. 104, "They couldn't be closer . . ." Ibid., 296.

p. 105, "It's really a sad . . ." Ibid., 299.

p. 106, "As you already know . . ." Ibid., 305.

p. 106, "this winter has been . . ." Ibid., 306.

p. 106, "I'll play your . . . won't worry me," Ibid., 306-307.

p. 107, "numerous wars waged by . . ." Citron, *Letters of Fanny Hensel to Felix Mendelssohn*, 310.

p. 107, "A more happy end . . ." Hensel, *The Mendelssohn Family*, 178.

p. 109, "She plays ravishingly well," Tillard, *Fanny Mendelssohn*, 305.

p. 109, "He stayed here for . . ." Tillard, *Fanny Mendelssohn*, 306.

p. 109, "His presence was a . . ." Ibid.

p. 110, "Yesterday, the final Sonntagsmusik . . ." Ibid., 311.

p. 111, "Last Sunday we had . . ." Ibid., 312.

p. 111, "Keudell keeps my music . . ." Hensel, *The Mendelssohn Family*, 325.

p. 112, "I have Herr Bock's . . ." Jane A. Bernstein, *Women's Voices across Musical Worlds*. (Boston: Northeastern University Press, 2004), 28.

p. 112, "May you have much . . ." *Fanny Mendelssohn/ Clara Schumann. Piano Trio. The Dartington Piano Trio*. CD-ROM. Hyperion, 1988.

p. 112, "At last Felix has written . . ." Citron, *Letters of Fanny Hensel to Felix Mendelssohn*, 326.

p. 113, "we have nothing left . . ." Hensel, *The Mendelssohn Family*, 337.

Bibliography

Bernstein, Jane A., ed. *Women's Voices Across Musical Worlds.*
Boston: Northeastern University Press, 2004.

Bowers, Jane, and Judith Tick. *Women Making Music:
The Western Art Tradition, 1150-1950.* Urbana, IL:
University of Illinois Press, 1987.

Briscoe, James R., ed. *Historical Anthology of Music by Women.*
Bloomington, IN: Indiana University Press, 1987.

Citron, Marcia J. *The Letters of Fanny Hensel to Felix
Mendelssohn.* Stuyvesant, NY: Pendragon Press, 1987.

Cooper, John Michael, and Julie D. Prandi, eds. *The
Mendelssohns: Their Music in History.* New York:
Oxford University Press, 2002.

Elvers, Rudolf, ed. *Felix Mendelssohn: A Life in Letters.*
Translated by Craig Tomlinson. New York: Fromm
International, 1986.

*Fanny Mendelssohn, Clara Schumann: Piano Trio/
Dartington.* CD-ROM. London: Hyperion, 1988.

Halstead, Jill. "Fanny Hensel: Life & Music." Music for
Pianos, http://musicforpianos.com/fannylifemusic.htm.

Harding, James. *Gounod.* New York: Stein & Day,
Publishers, 1973.

Hensel, Sebastian. *The Mendelssohn Family (1792-1847)
from Letters and Journals.* New York: Greenwood
Press, Publishers, 1968.

Jezic, Diane Peacock. *Women Composers: The Lost
Tradition Found.* New York: The Feminist Press, 1988.

Kupferberg, Herbert. *The Mendelssohns: Three Generations*

of Genius. New York: Charles Scribners' Sons, 1972.

Neuls-Bates, Carol. *Women in Music: An Anthology of Source Readings from the Middle Ages to the Present.* New York: Harper & Row, Publishers, 1882.

Nichols, Janet. *Women Music Makers: An Introduction to Women Composers.* New York: Walker and Company, 1992.

Pendle, Karin. *Women & Music: A History.* Bloomington, IN: Indiana University Press, 1991.

Rothenberg, Sarah. "'Thus Far, But No Farther': Fanny Mendelssohn-Hensel's Unfinished Journey." The Musical Quarterly, Volume 77, Number 4, Winter 1993.

Sadie, Julie Anne, and Rhian Samuel, ed. *The New Grove Dictionary of Women Composers.* London: Macmillan Publishers, Ltd., 1994.

Smith, Gail, "Tribute to Fanny Mendelssohn Hensel." Creative Keyboard, http://www.creativekeyboard.com/feb05/tribute.html.

Tillard, Francoise. *Fanny Mendelssohn.* Portland, OR: Amadeus Press, 1992.

Todd, Larry R. *Mendelssohn: A Life in Music.* New York: Oxford University Press, 2003.

———. *Mendelssohn and His World.* Princeton, NJ: Princeton University Press, 1991.

The Women's Philharmonic: Lili Boulanger, Clara Schumann, Germaine Tailleferre, Fanny Mendelssohn. CD-ROM .Westbury, NY: Koch International Classics, 1992.

Web sites

http://www.hyperion-records.com/notes/67110.html
Hyperion Records, an independent British classical label, features a biography of Fanny Mendelssohn Hensel on this Web site, as well as a discussion of her musical works.

http://www.female-ancestors.com/daughters/mendelssohn.htm
This site, which bills itself as a resource to help women to find their ancestors, provides a lenghthy biographical piece on Fanny Mendelssohn.

http://www.biu.ac.il/HU/mu/min-ad/06/Fanny_Mendelssohn.pdf
This Web site links to a thirteen-page article titled "The Roman Holiday of Fanny Mendelssohn." The article evolved from a seminar on the Mendelssohn family given at Bar Ilan University, Israel by Beth Shamgar on the occasion of Fanny's two hundredth birthday anniversary.

Index